IMAGES
of America

EARLY BISBEE

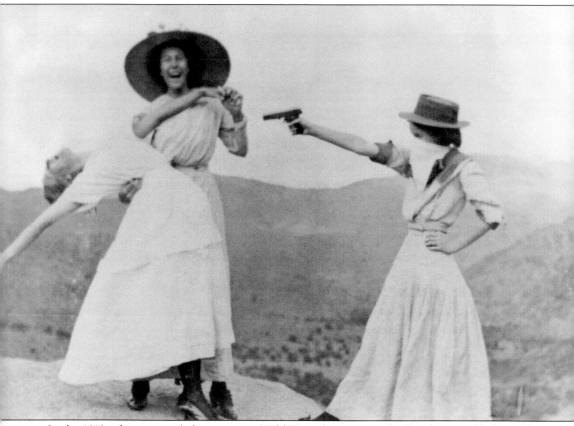

In the 1910s, three young ladies reenact a Wild West shoot-out in the Divide area of Bisbee. This photograph was taken when actual such events were in the not-so-distant past. The Wild West had only ended in the Mule Mountains a couple decades before. (Courtesy of the BM&HM.)

ON THE COVER: Bisbee's infamous Brewery Gulch is shown in the early 1900s. This period was the city's heyday. Men meandered up the gulch to find a place to grab a shot of whiskey, do a bit of gambling, or find the companionship of a woman. (Graeme-Larkin collection.)

IMAGES
of America

EARLY BISBEE

Annie Graeme Larkin, Douglas L. Graeme,
and Richard W. Graeme IV

ARCADIA
PUBLISHING

Published by Arcadia Publishing
Charleston, South Carolina

Printed in the United States of America

Library of Congress Control Number: 2014959563

For all general information, please contact Arcadia Publishing:
Telephone 843-853-2070
Fax 843-853-0044
E-mail sales@arcadiapublishing.com
For customer service and orders:
Toll-Free 1-888-313-2665

Visit us on the Internet at www.arcadiapublishing.com

To our parents, Richard W. Graeme III and Nina Graeme,
who taught us to love and respect Bisbee's past.

CONTENTS

ACKNOWLEDGMENTS

It is impossible to take on such a project without having the support of numerous people. This is truest of our spouses, Pam, Lisa, and Vance. Without the love and encouragement from our significant others, our vision of sharing Bisbee's early history would have remained only a vision. Because of them, this idea became a reality. However, the person who made the greatest sacrifice during this project was Richard W. Graeme V. Thank you for your love and understanding while your father was fulfilling a dream. We would also like to thank other family members, including Ursula, Jennifer, Ashley, Joe, our parents, and the Youngs family. Thanks also to the staff at Arcadia Publishing for their guidance during this process. Many of the images within the book are from the photograph collection of the Bisbee Mining & Historical Museum (BM&HM). Unless otherwise noted, all of the images in the book are from our family's collection.

INTRODUCTION

On the yellowed, brittle paper of the 1854 map sketched for the Gadsden Purchase, the area that would become Bisbee was blank. During the westward migration, this portion of the Southwest was bypassed. Pioneers faced the high desert's uncertain supply of water and game. For most explorers, this would have been the primary concern; but here, just staying alive was uppermost in their minds. This was one of the last fighting grounds of the Indian Wars, and the Chiricahua Apaches fiercely protected their lands from intruders. For those who dared to enter the unsettled region, their only protection was the Winchester in their saddle. But the forces that sent people West fueled the desires of some to journey into the dangerous lands. The *Arizona Citizen* stated that desperate prospectors believed "that poverty alone lurked in the rear and [were] somewhat mixed as to whether scalps or fortune hung in the front."

The treacherous mountain range that sheltered Bisbee was initially considered the Lower Dragoons. Legends tell of steep-walled canyons filled with Apache plunder, including numerous mules taken from ravaged Mexican settlements. An 1881 newspaper states that these actions gave the mountain range a new name, Sierra de las Mulas, the Mule Mountains. Conflicting legends claim the area was named for its abundance of mule deer.

The Mule Mountains were known to be "dark and bloody" grounds, where the Apaches and outlaws took advantage of the close canyons and rugged terrain to ward off unwelcome visitors. In an effort to enable Americans to exploit the natural resources of the area's untouched land, the US Cavalry moved into the region. Fort Bowie was established in the eastern portion of modern-day Cochise County in 1862. Then, in 1877, the western section became the site of Camp Huachuca. With these military installations established, people began to move into the area.

The first reported journey into the canyon was led by Major Brayton, with a scout named George Warren, around 1869. The men were following the trail of the Apache leader Cochise when Warren noticed rocks containing copper. Duty required the men to continue their hunt for the elusive Cochise, and they moved on. In the winter of 1875, "a bold and enterprising" prospector named William Garrett entered the Mule Mountains and found evidence of a mineral deposit. However, the find became less intriguing when he also discovered signs that Apaches had recently been in the area. His instincts for survival being stronger than for wealth, the man made a hasty retreat out of the mountains. When Garrett returned to Tucson, he showed the ore samples to D.B. Rea and Maj. William Downing. His efforts involved recruiting men for an expedition to investigate the discovery. However, a group of Apaches, with tempers flared, broke out of the reservation near Fort Bowie. On the "warpath," they took the lives of numerous people who had invaded their land along the Sulphur Springs Valley and the upper San Pedro River. As a result, exploration of the area came to a standstill, leaving the tantalizing possibility of mineral wealth unobtainable.

In 1876, the hunt for the renegade Apaches led the 6th US Cavalry into the Mule Mountains. The cavalry party included Indian Agent Tom Jeffords and the son of Cochise, Chief Taza. The

men traveled up into what would become known as Mule Gulch. Upon approaching a jagged iron ore outcropping, near what would become the Copper Queen Mine, a battle erupted between the fugitive Apaches and the cavalry. The Apaches utilized the impenetrable rock as a natural fortification to defend themselves from the pursuers. Under the hail of bullets, Taza pleaded with his tribesmen, to no avail. Accepting that further conflict was futile, the cavalry retreated.

According to the *Arizona Weekly Citizen*, in the winter of 1877, D.B. Rea, along with army scout and guide George Warren, set out to find the "El Dorado of their expectations." Heading east not far from the San Pedro River, the men followed an "old Indian trail," leading them into the Mule Mountains toward Mule Gulch. Along this rugged trail, they rode upon "a human skeleton, apparently that of a girl or small woman—probably some poor, weary emigrant or Mexican captive who had fallen or left to perish by her cruel captors on the way to this ill-fated mountain castle." Not far from the tragic remains of the woman, the unmistakable signs of Apaches herding their latest plunder of cattle were evident. Realizing the potential danger ahead, the men withdrew.

Later that year, members of the 6th Cavalry, including Lt. John Anthony Rucker, scout Jack Dunn, and T.D. Byrne, entered the foreboding Mule Gulch. Rucker and Dunn are documented as being battle-hardened Indian fighters in the Southwest. When the soldiers reached the vicinity of the rocky outcropping where the previous skirmish took place in 1876, they, too, discovered signs of mineral wealth. The difference between this and former discoveries is that Rucker, Dunn, and Byrne acted upon their find. The men located the first claim in Mule Gulch, called the Rucker, which included the jagged outcrop that the Apaches used to successfully hold off the cavalry. Despite their interests in the area, the experienced Indian fighters were obligated to answer their call of duty to the military.

On the journey, they grubstaked the weathered prospector George Warren, who was previously repelled by the Apaches from exploiting his discoveries. Local lore insinuates that this was the first time Warren entered this section of the Mule Mountains. However, newly discovered information now places him in the region almost a decade earlier, when he traveled to the area with Major Brayton. Now tasked to locate claims, he reentered the perilous canyon and began to stake claims. However, he unscrupulously omitted his partners Rucker, Dunn, and Byrne as co-owners of the claims. The news reached prospectors of the ores hidden in the Mule Mountains like the plunder once concealed by the Apaches.

And so Bisbee begins. . . .

One

SIERRA DE LAS MULAS

In 1872, the US government established the Chiricahua Apache Reservation in southeastern Arizona. The land extended from the Mexican border north to near present-day Safford, Arizona, and to the western edge of the lower Dragoon Mountains. This included their traditional homeland of the Chiricahua Mountains and their hideaway in the lower Dragoons, called the Sierra de las Mulas, the eventual site of Bisbee. By 1876 the reservation had dissolved, opening the area for prospecting and settlement. However, the removal of these imaginary borders did not make the area safe. This frontier continued to experience turmoil due to a continued presence of the betrayed Apaches.

Gradually, the Sierra de las Mulas became populated with prospectors. This included George Warren and D.B. Rea, who were finally able to investigate the mineral wealth within Mule Gulch. This location became known as Warren and Rea's Camp. One of the mining claims in this camp, the Copper Queen, made a glorious ascent into fame. Originally, the ground was staked as the Halcro claim. Seeking the next Tombstone, the initial owners of the claim desired silver, but only found stains of copper. Disgusted, they neglected to meet their legal obligation of putting $100 of work into the claim. With the clock ticking toward December 15, 1878—the claim's impending expiration—George Eddlemen and Marcus Herring re-staked the claim, known as the Copper Queen, after the deadline elapsed. Mere ownership does not develop a claim. Being located in an isolated area without resources or infrastructure, and with a looming Apache threat, hindered the mining operation in its infancy. To battle these challenges, and to advance the property, investors and mining experts were sought. One of these men, Judge DeWitt Bisbee, was a metallurgy and mining expert. He made such a significant contribution to this tiny camp that it was given the name Bisbee.

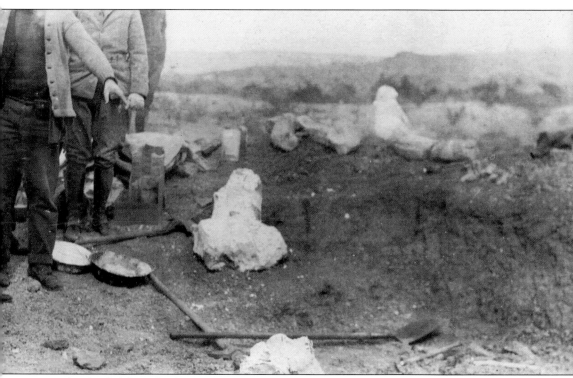

In the clouded days of prehistory, over 11,000 years ago, mankind was already exploiting the Bisbee area. The climate was 10 degrees cooler and receiving in excess of 20 inches of rain each year. Mammoth, tapirs, and bison roamed the rich grasslands dotted with trees along perennial streams. Early man, armed with spears tipped with the skillfully fashioned "Clovis" points, hunted along these muddy streams. They cleverly trapped mammoth by allowing them to enter the streams and then stifled their movements in the deep mud. The animals thus became easy targets for the hunters. Multiple kills and campsites have been found within 15 miles of the community. This photograph captures an early excavation of mammoth bones. Archaeologist Vance Hanes expressed the importance of the mammoth kill sites, stating that they are "one of the earliest evidences of man in the New World." (Courtesy of the BM&HM.)

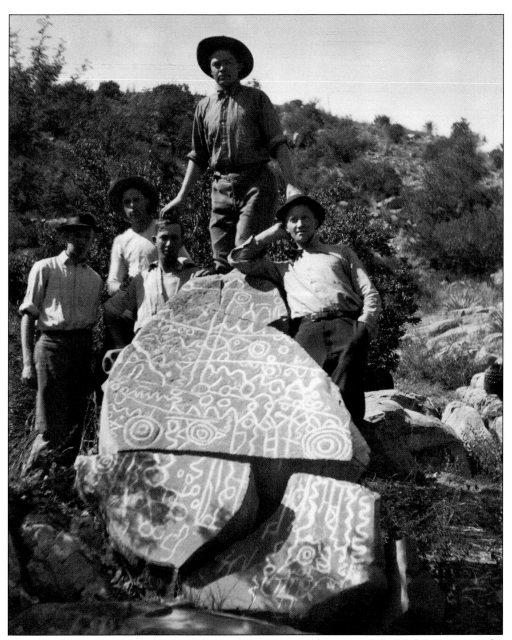

Centuries before the Chiricahua Apaches and American settlers entered the Mule Mountains, the Hohokam called this region home. Ancient Bisbee is well known within archaeological circles, yet these wondrous discoveries are often overlooked by the local population. The Hohokam lived on the northern side of the Mule Mountains, with evidence of their campsites within Mexican and Abbot Canyons. Fragments of their legendary Red on Buff Pottery, with boldly decorated designs, peeked through the earth, hinting at their existence. Fire pits and a delicately placed skeleton, with its hands cupped and legs drawn in a fetal position inside of a "burial vault," were found. Another skeleton was indiscriminately dumped into a grave, covered with boulders, creating a mystery of the person's identity. Silent pictographs, painstakingly carved on sandstone boulders, are the sole reminders of these ancient inhabitants of the steep canyons of Bisbee.

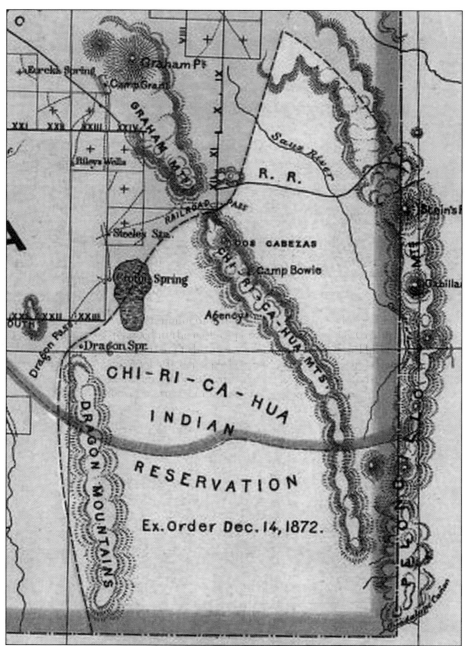

In 1876, the US General Land Office released a map of the Arizona Territory. This image vaguely illustrates the southeastern corner of the territory. Obvious from the lack of detail, surveyors spent little time examining the region, perhaps due to the unpredictable relations with the land's residents. At this time, the area included the Chiricahua Apache Indian Reservation, which stretched from the Mexican border 100 miles north into Arizona. To the east and west, their land was naturally bounded by the Peloncillas and Dragoon Mountain ranges. The present-day community of Bisbee is located about where the "S" is in the area labeled "Dragoon Mountains" and was considered part of the Apache Reservation. The lower end of the Dragoons was not a place for uninvited guests such as prospectors and settlers. (Courtesy of Library of Congress.)

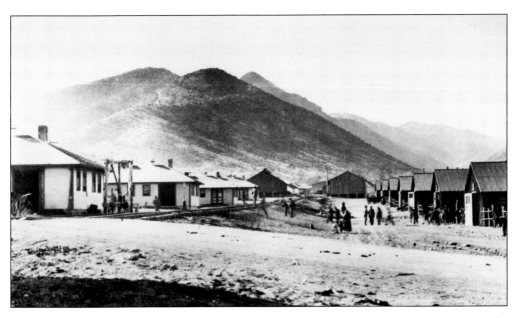

In an effort to enable American immigrants to settle the land, the US military moved into the region. Fort Bowie was founded in the eastern portion of modern-day Cochise County in 1862. Then, in 1877, the western section of the area became the site of Fort Huachuca (above). With these military installations established, people began to move into the area. Below, Apache scouts and US Cavalry pose on a jagged hilltop near Bisbee. This rocky area is believed to be the crest of Sacramento Hill. (Above, courtesy of Library of Congress.)

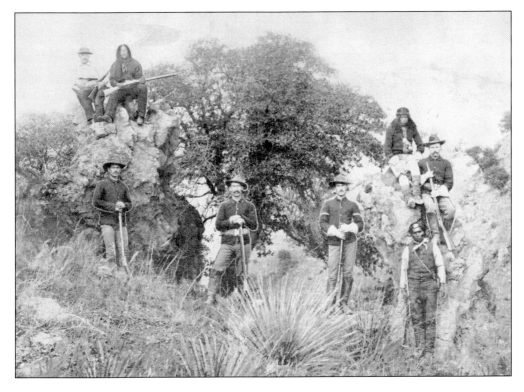

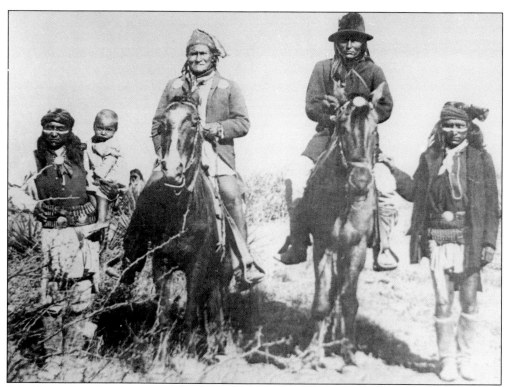

The Chiricahua Apache were a nomadic people, and the US government had imposed borders that forcefully contained them to their assessed land. While some of the Chiricahua were resigned to the fate of living on a reservation, others did not want to accept a life defined by the US government. This included Geronimo, shown above third from right in 1886. Fighting the occupation of his home, Geronimo led bands of Apaches who defiantly left the reservation and traveled throughout southeastern Arizona and northern Mexico. Those who followed Geronimo included not only warriors, but families with women and children. Dreams of returning to their old lives proved to be unobtainable because of the encroachment of settlers and prospectors into their lands. (Above, courtesy of Library of Congress; below, courtesy of the BM&HM.)

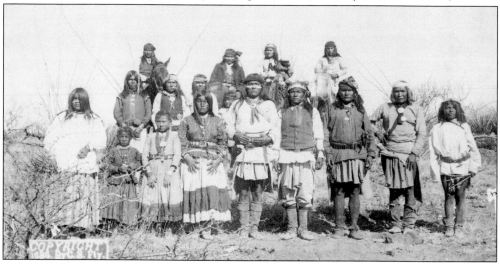

One of the people responsible for the encroachment of the Apaches' land was George Warren. He was among the first American immigrants to enter the Mule Mountains. Seasoned to a hard life, Warren was a government scout and prospector. During his youth in New Mexico, his father had been killed, and Warren was captured and held prisoner by Native Americans. Eventually gaining his freedom, he traveled to Arizona and became a scout. Thus employed, he made his first trip to Mule Gulch and recognized evidence of a copper deposit. Despite his interest in the deposit, the danger of an attack from the Apaches in the Mule Mountains was too great. Nearly a decade passed before Warren was be able to return. Due to the incalculable contributions he made to the area's mining development, the region became known as the Warren Mining District.

In 1877, Army scout Jack Dunn (left), with Lt. John Anthony Rucker (below) of the US 6th Cavalry, were assigned to pursue an escaped band of Apaches. Their search led them into the Mule Mountains, where they camped at Iron Springs. Dunn was sent out to search for a satisfactory water source. He found water at the base of a cliff, and upon returning to the encampment, found ore in place. This was cerussite, a lead ore that can contain a large amount of silver. Excited that they possibly found a silver mine, along with T.D. Byrne, they staked a claim. These men mistakenly grubstaked with prospector George Warren, who would conveniently forget to record them as part owners of future mining claims. (Both, courtesy of the BM&HM.)

At the bottom of a canyon, beneath a tall gray limestone cliff, hidden within the twisted limbs of scrub oak and across from a refreshing spring, D.B. Rea and George Warren built a humble rock cabin. The dwelling is hidden in this photograph, in the lower right corner behind the oak trees. The towering limestone mass that sheltered the cabin is one of the few unchanged landmarks in Bisbee and is known as Castle Rock. The spring that flowed at this geological landmark was the same that Jack Dunn had located a few years prior. In 1878, Rea went on to build the first crude smelter in Bisbee. Warren was the owner of several claims in the fledgling mining camp. This is one of the earliest existing photographs of Bisbee. (Courtesy of the BM&HM.)

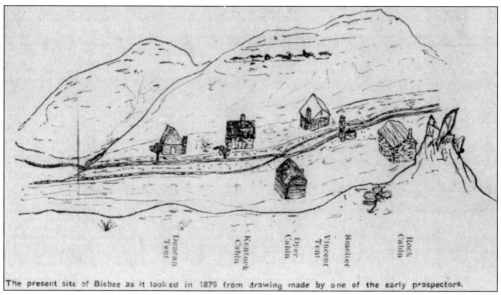

The present site of Bisbee as it looked in 1879 from drawing made by one of the early prospectors.

George Warren and D.B. Rea's development of mining claims in the Mule Mountains prompted people to venture into the foreboding canyons. Soon, a meager tent community called Warren and Rea's Camp was home to fortune-seekers. By 1879, the fledgling mining camp consisted of two tents, three cabins, and Rea's crude smelter.

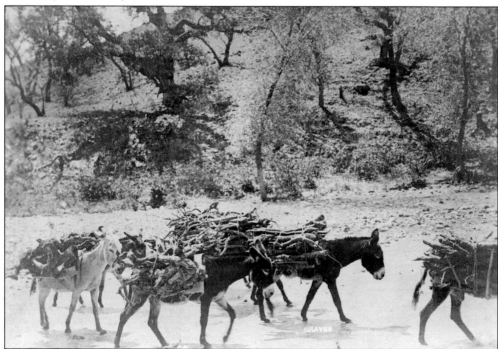

The isolated nature of the mining camp left it vulnerable, and outlaws took advantage of this. In August 1879, when they raided Warren and Rea's Camp, according to the *Phoenix Herald*, these "Rascally Renegades" comprised of desperate "Americans, Mexicans, and Indians" stole precious livestock. The loot the bandits rode off with would have crippled every aspect of the camp's survival.

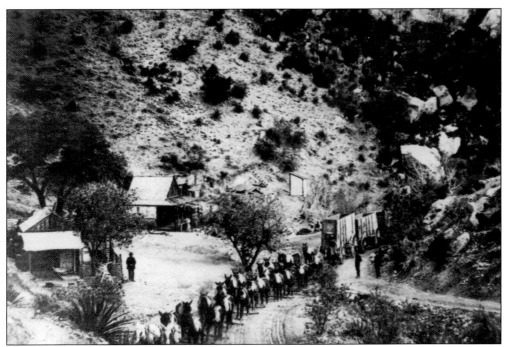

Animals were the lifeblood of the early camp; only with their assistance could the community survive. They offered sustenance and transportation, and hauled heavy cargo. Here, a 24-mule team pulls an ore train past Castle Rock as the copper makes its way to the Eastern metals market. (Courtesy of the BM&HM.)

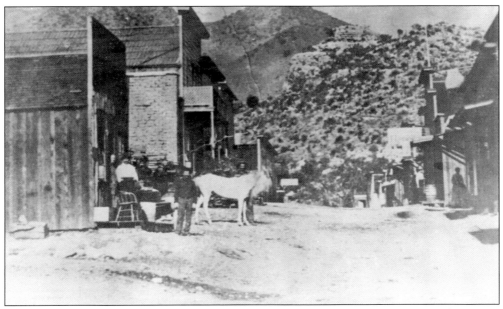

In the early 1880s, Warren and Rea's Camp witnessed a period of significant growth, as seen in this photograph of Main Street. Restaurants, saloons, and a mercantile were established, as well as key components of infrastructure, including a post office. In addition, peace officers were appointed. The camp also adopted the name Bisbee. (Courtesy of the BM&HM.)

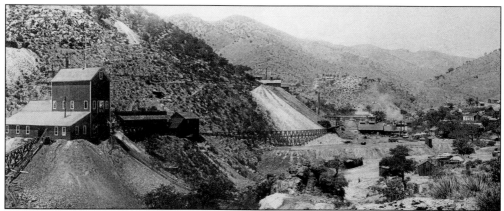

Within a few years, the mines employed over 600 men. Expanding mining operations continually needed a skilled workforce. The new workmen were faced with a difficult journey to Bisbee. In the center foreground of this photograph is the Iron Monster, a rock outcropping. It was here that the early battle between the US Cavalry and Apaches occurred. The Czar Mine is on the left, and the Copper Queen Mine is at center.

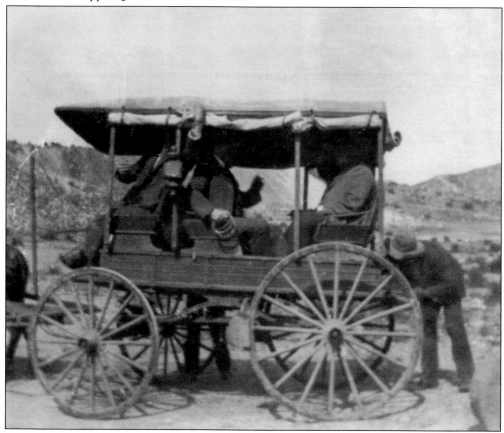

Prosperity and growth warranted the development of a stage line to Bisbee. Initially, transportation was offered from Charleston in 1880, courtesy of a buckboard wagon. With time, multiple stage lines made the journey into Bisbee. The stage route was south along the San Pedro and north into Bisbee. This isolated road made the stage vulnerable. (Courtesy of the BM&HM.)

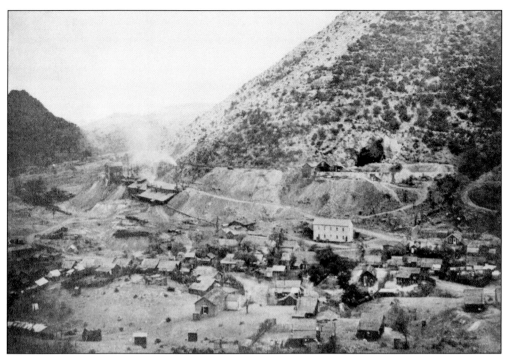

Legends tell that mining company officers were horrified when they entered Bisbee and discovered the remains of a man swinging from a tree after a lynching at the base of Castle Rock. Feeling that only education could tame such a community, the development of a book-borrowing program began. In 1884, books could be borrowed from the Copper Queen offices. An official library opened in 1887. The first library, seen above, is the white two-story building that towers above the miners' homes. In 1892, the second library was built, offering a smoking and game room, as well as an expanded selection of reading materials. The photograph below affords a view of the substantial second library, constructed of brick with expansive porches.

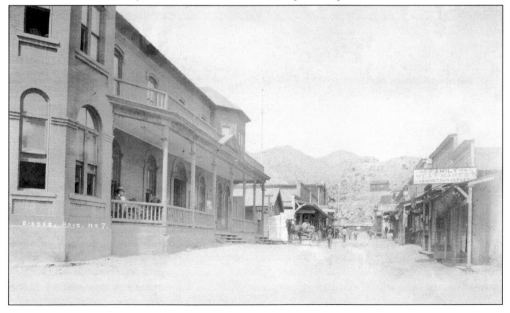

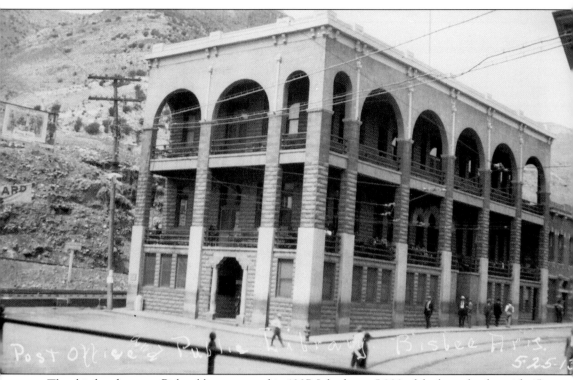

The third and present Bisbee library opened in 1907. It had over 5,000 of the latest books, with 45 magazines and 25 newspapers in multiple languages. Reading materials were housed on the third floor, and comfortable areas for reading were provided on the second floor. By 1910, the average daily attendance was 261 patrons. Through most of the early years, the library and US Post Office in Bisbee have often been housed in the same building. The first floor has served as the post office since 1907. Originally, it was paneled in oak, with ornate brass grilled service windows and 2,000 decorated brass post-office boxes. It was necessary for all residents to have a box, as postal carriers could not be persuaded to deliver mail to each home up the many staircases.

The next improvement made to the town after the library was the railroad. In 1888, the Copper Queen Consolidated Mining Company was struggling to haul all the copper, coke, and timber by mule teams. The Arizona & Southeastern Railroad was formed, making its first trip into Bisbee on February 1, 1889. Here, a train steams past the rugged slopes of Sacramento Hill on the outskirts of Bisbee.

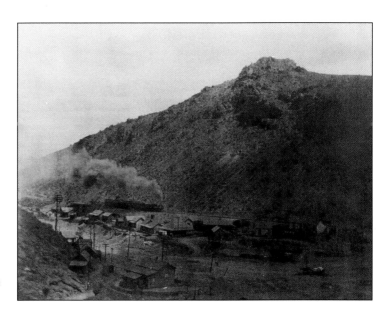

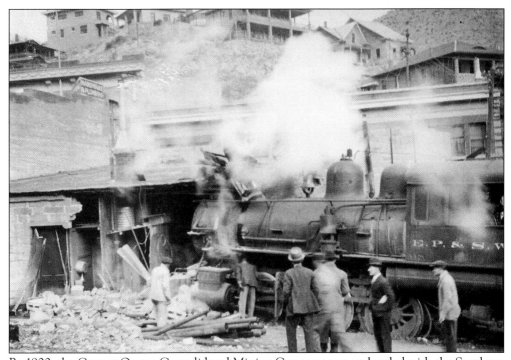

By 1900, the Copper Queen Consolidated Mining Company was embattled with the Southern Pacific Railroad. Under the direction of James Douglas, the Arizona & Southeastern was expanded and became the El Paso & Southwestern Railroad. As with all railroads, it had problems with runaway cars and derailments. This smoking locomotive has smashed into a brick building near Main Street.

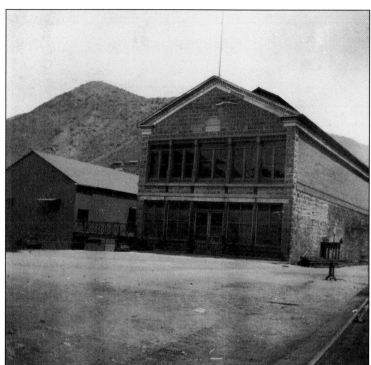

The Copper Queen Consolidated Mining Company realized that the supplies and quality of merchandise sold in Bisbee was unpredictable. In 1886, the company purchased a store from Mary Crossey and ordered a large stock of goods. The Copper Queen Store offered stoves, flour, dresses, guns, toys, and even dynamite.

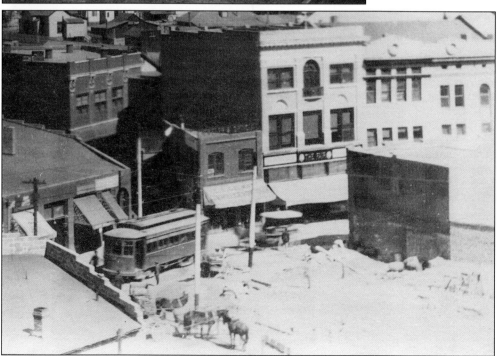

The Fair Store opened in 1899 on Main Street. This department store offered serious competition to the Copper Queen Store, selling fashionable clothes, shoes, and linens of a superior quality and style. Bisbee was never the stereotypical "company town," as stores like the Fair offered alternative places to shop.

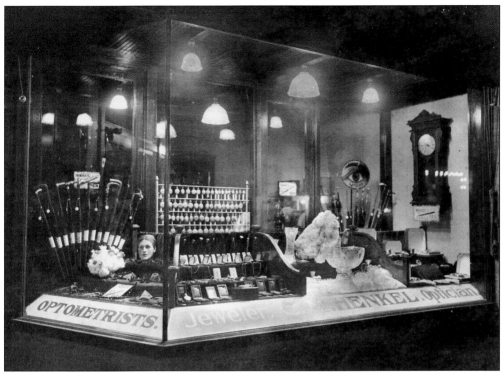

Bisbee became a market for luxury goods. In 1898, Claud Henkel opened a small jewelry shop that presented diamonds, expensive gold watches, sterling silver, and glittering cut glass. Other stores sold a wide variety of toys, including Madonnas, cigarette fiend dolls, swords, and windup battleships. Objects of more local interest were also stocked. Jewelers sold beautifully polished azurite and malachite from the area mines, set in gold, along with Mexican *zarapes* and Navajo blankets. The fine cut glass punch bowl in the window display above would have cost around $100 in 1904, a month's wages for a miner.

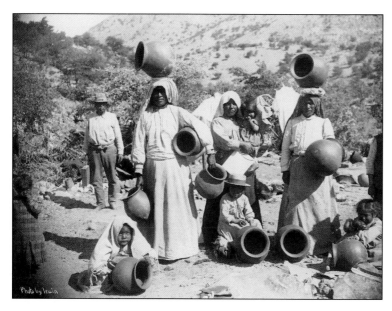

Wandering groups of the Tohono O'odham people visited Bisbee to make and sell their popular *ollas*. Residents used these finely made jars to store and cool precious drinking water. This was a land once dominated by Native Americans, but southeastern Arizona's population was changing.

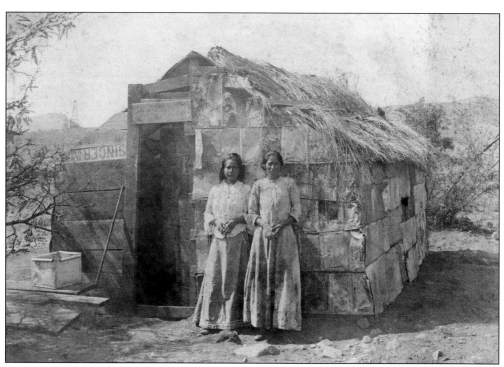

Early settlers found it necessary to repurpose materials, due to the high cost and limited supply of resources in the rural area. Wooden crates and flattened metal cans are being used as siding on this home. Abundant dynamite boxes were also commonly used for building materials and to make furniture.

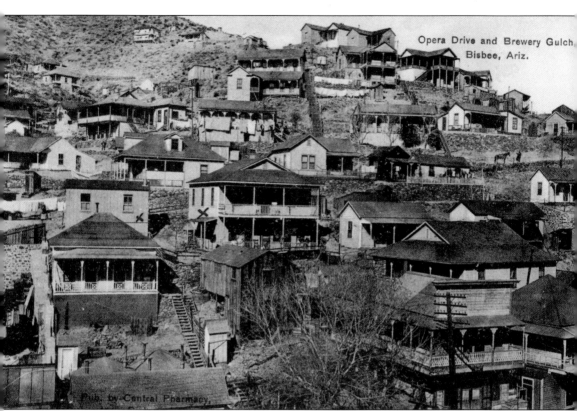

Opera Drive and Brewery Gulch, Bisbee, Ariz.

Pub. by Central Pharmacy.

As more people called Bisbee home, finding a place for new residents to build a house proved to be challenging. Early inhabitants took the prime real estate, leaving newcomers to look toward the steep hills to erect their abodes. Likening homes to cliff dwellings, residents were said to have created foundations by digging into the sides of hills. This created level ground and then surrounded the area with stone walls as residents built their homes. The backs of the houses were built against the hillside, which often reached a second story that was level with the earth. This would be where the children's quarters were maintained, so that the young ones would not risk falling out of windows. Residents constructed countless steps and ladders to reach these homes, often located hundreds of feet above the streets.

Shown above, the first schoolhouse was a simple building near Castle Rock on the edge of town. This school was started in 1881, with five students and Clara Stillman as the teacher. Desks and chairs were fashioned from shipping barrels and crates. A mine whistle sounded if Apaches were sighted. After a second warning, the schoolchildren would take refuge in the tunnel near Main Street. The location was dangerous, and the school was relocated closer to town. In 1883, the Copper Queen Mining Company donated a new adobe building constructed in a safer location (below). Improvements continued to the building, including blackboards, a teacher's desk, and maps. That year's teacher, Daisy Robinson, faced a challenging class. Her 20 students were from six different countries. (Courtesy of the BM&HM.)

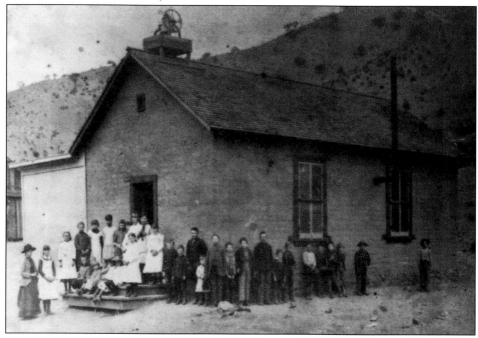

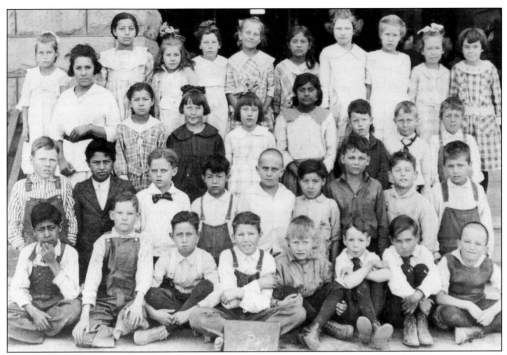

Bisbee schools were flooded with multicultural children, and teachers soon became concerned. The younger grades were filled with students from different countries, but this number dropped to almost none in the higher grades. The above photograph shows a third-grade class at Central School; a high school class is seen below. Following fashionable education theories, segregated schools and classrooms were tried for a short time in an attempt to keep students in school. Young men often quit school around the age of 16 to work in the mines, where they could secure positions such as tool nippers. A night school was started, specifically designed for boys 14 and older who worked in the mines. Its sessions were organized around mine shift changes. (Courtesy of the BM&HM.)

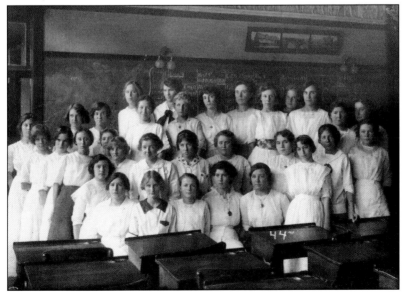

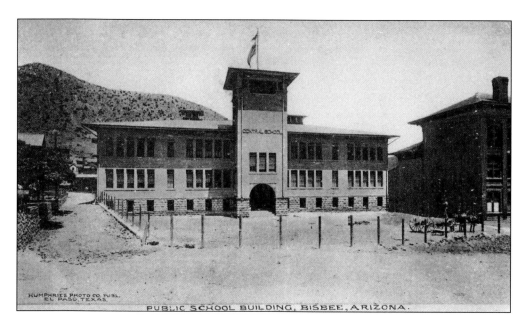

PUBLIC SCHOOL BUILDING, BISBEE, ARIZONA.

Between 1902 and 1906, the number of students doubled. Typically, nine schools were operating. Many of these were small and short-lived, such as Booker T. Washington, which operated for around six years and served African American children. Until the construction of Bisbee High School on Clawson Hill (below), the largest school was Central School (above), with close to 600 students. Upon graduation from college, Elsie Toles, a 1906 graduate of Central School, returned to teach there in 1909. Originally, education was offered up to the eighth grade; high school classes were quickly added. The teachers had degrees from out-of-state universities, and some were multilingual. By 1917, the University of Arizona was interested in using the Bisbee School District as part of its teaching program.

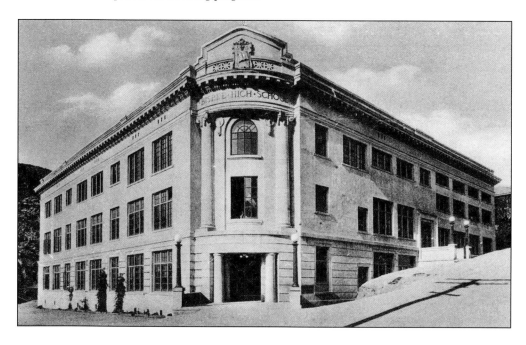

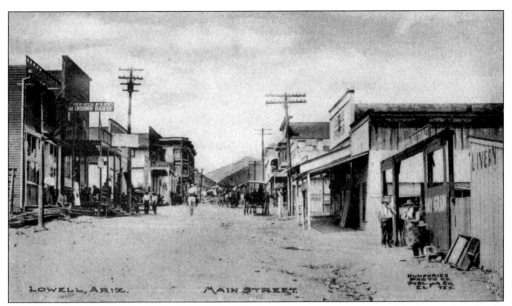

As it became clear that Bisbee's fruitful ore deposits were not going to quickly diminish, suburbs began to sprout up within the mining district. This included Lowell, a successful community in its own right. Erie Street, the main thoroughfare of the city, had numerous stores and, of course, saloons.

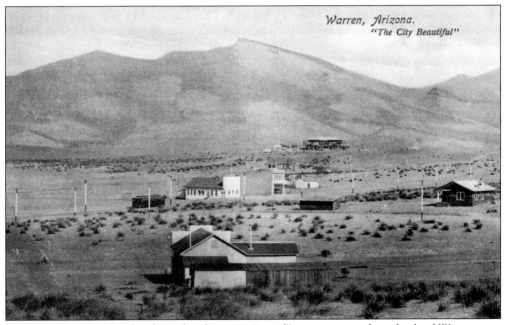

For those individuals who desired to live in a "moral" community, the suburb of Warren was developed. The community had numerous amenities, including a vast park, ballpark, churches, and schools. Being the decent community it was designed to be, it lacked saloons. Warren would also house the newly established transportation system, the Warren-Bisbee Railway.

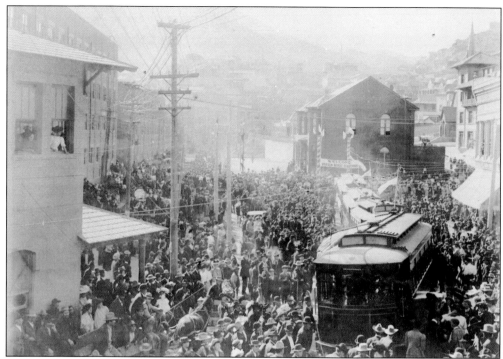

The development of the Warren-Bisbee Railway began in 1907. The transit system linked the major parts of the community. When the proposal was initially suggested, it was laughed into ridicule, as it was believed that Bisbee's terrain would not enable such a service. The task was not simple, but it was doable with the proper planning. In March 1908, the railroad reached Bisbee, and the city responded with jubilation. An immense celebration was planned, and 3,000 spectators attended. Besides the Fourth of July celebrations, Bisbee had never witnessed such crowds. The streets, windows, and balconies were filled with residents, and men even climbed telegraph poles to witness the momentous occasion.

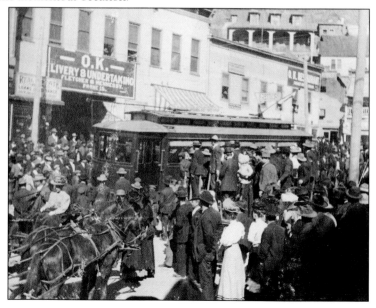

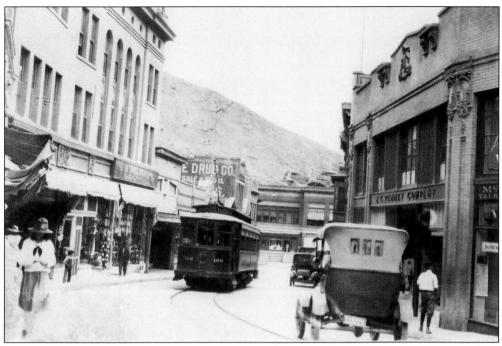

In a city where transportation was once confined to burros and pack mules, the amenities of the 20th century finally arrived in the form of the Warren-Bisbee Railway. This was a momentous day for the mining camp. The mayor requested the city close for a few hours of celebration. As the first car approached, dynamite salutes were discharged from the old Copper Queen Mine, mine sirens blared, and bands played patriotic music. The initial passengers on the cars included 200 of the city's prominent businessmen. The first car was driven by Charles Adsit. The mayor and local dignitaries gave speeches, expressing their pride in Bisbee's success. Fares were 5¢ between the local communities, and ticket packets could be purchased at discounted rates. On March 12, ladies were given the pleasure of riding the streetcar free of charge.

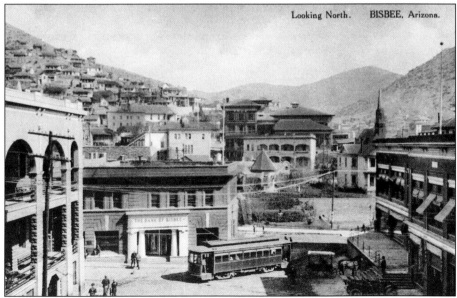

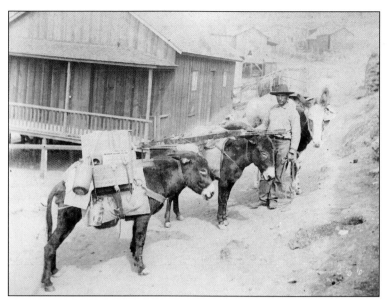

The use of burros enabled Bisbee residents to have water and necessities transported to their doorsteps. With many individuals living on the steep and rocky hillsides of the town, wagons proved ineffective for hauling, and performing such a task unaided would be torturous. Consequently, the burro system became widely used among residents.

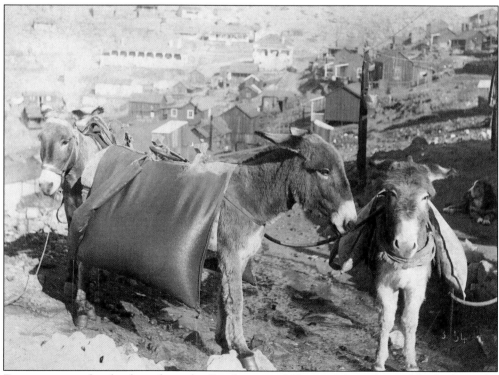

Burros were used to haul ore from the Southwest and Higgins Mines, located high above the city. However, their most important use was in transporting water. Burros carried two canvass sacks, one hanging from each side. These bags were evenly filled and contained approximately 20 gallons of water.

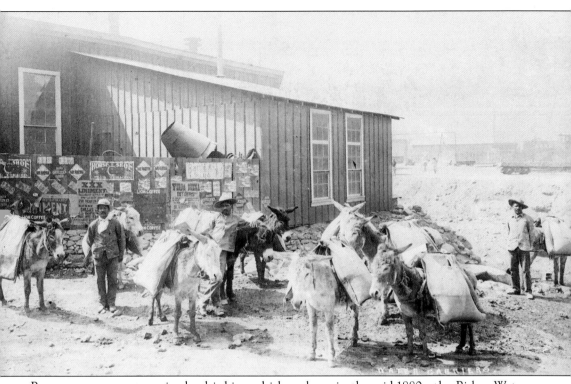

Because one cannot survive by drinking whiskey alone, in the mid-1880s, the Bisbee Water Works was established. Residents initially turned to springs in the area for their water source. However, these springs were undoubtedly subject to weather conditions, as a lack of rain or freezing temperatures would hamper one's ability to acquire the much-needed resource. The conditions in this Western camp quickly began to be transformed. Within the next 20 years, Bisbee experienced a dramatic population increase and endured some of the hardships faced by quickly constructed frontier boom towns. For approximately 20 years, rugged burros were the system of water distribution for countless homes and businesses. Soon, the residents found the vital springs dry or contaminated. The Bisbee Water Works developed wells that sufficed for the early population, but they were poorly located.

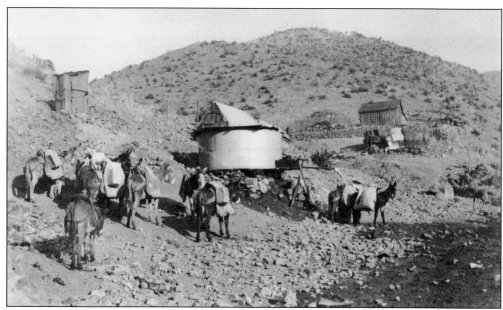

One well in Brewery Gulch was 20 feet from the cemetery and downhill from outhouses. Another was less than 200 feet downhill from an outhouse. In addition, sewage was witnessed trickling down and flowing within a few feet of the well. Shown here is a prime example of such poor well locations—a privy is uphill of and close to a local water supply, enabling contamination.

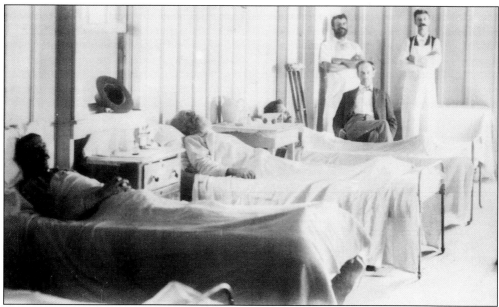

In 1896, Bisbee experienced a severe outbreak of typhoid fever; 75 people became ill, and 10 percent of the cases were fatal. Outbreaks of sickness plagued the camp. Frederick Farquhar inspected water supplies and found them to be frightfully close to contaminating sources. Water was blamed for the sicknesses. (Courtesy of the BM&HM.)

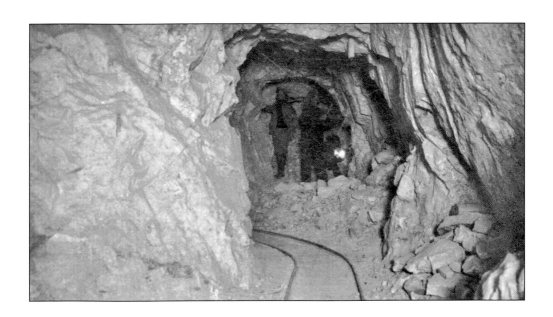

The first doctor in Bisbee was considered a drug addict and a "quack." In the early years, a small dispensary was located on Main Street. In 1883, an abandoned section of the underground mine (above) was used as an emergency hospital to treat typhoid patients. In 1900, the Copper Queen Consolidated Mining Company built the spacious Copper Queen Hospital (below) near the Holbrook Mine. The locations allowed easy access for injured miners and residents. Injured miners were regularly brought to the hospital directly from the mines where they were hurt. These hospitals served the entire population of the community.

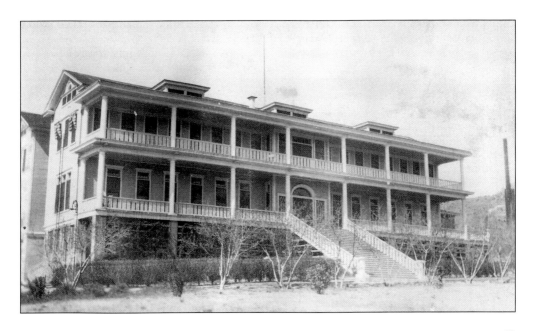

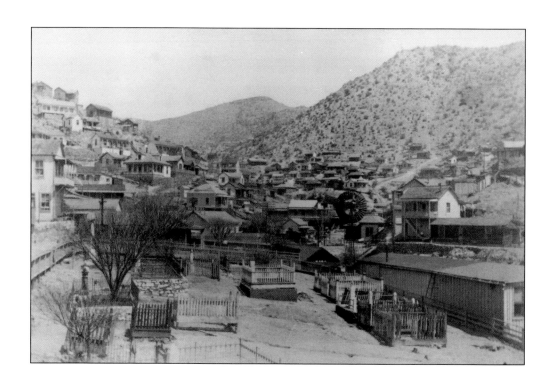

The *Bisbee Daily Review* stated, "Cleanliness is next to Godliness and some parts of town seem a long way from heaven." In an effort of redemption, Bisbee strove to clean up the community. This included moving the Brewery Gulch Cemetery away from one of Bisbee's water supplies. This proved to be a laborious task, as the Brewery Gulch Cemetery had been used since the 1880s. By the time the move took place in 1915, numerous graves were unmarked, providing those charged with the removal a test of their intuitive skills. They excavated all the remains they could find. The proximity to Central School traumatized children. Filled with grim curiosity, they watched the excavations and recounted gruesome tales. Ironically, the location was later transformed into the concrete-covered City Park. (Above, courtesy of the BM&HM.)

Two

HIDDEN WEALTH

Beginning during the Jurassic period, ancient oceans flooded Bisbee for eons, then receded, and mountains began to form. Magma hidden deep beneath the surface pushed its way upward, bulging the existing surface and creating the Mule Mountains. This tremendous strain shattered the surrounding rocks. Metal-bearing steam and hot water from the earthly depths were injected into the cracks about 180 million years ago. This fluid filtered through the broken rocks and deposited copper, gold, silver, lead, zinc, manganese, and sulfur. In these solutions, the metals often reacted with the sulfur to form metal sulfides. This event was repeated several times. Sometimes, the liquids carried unusual elements, like tellurium, vanadium, and bismuth. Over time, erosion exposed the rock containing the metal sulfides to weathering, resulting in an essential alteration. This oxidation, or rusting, of the rocks caused the metals to concentrate, creating blue azurite and green malachite ores, which made Bisbee's mines famous. The verdant stains of malachite stood out sharply against the gray limestone and brown iron-rich rocks. These hints of color gave George Warren a clue to the hidden treasures below.

Nature would not easily give up its wealth. It would have to be drilled and blasted, and it would be mined. In 1880, the Copper Queen Mine began in earnest with excavation of the "Glory Hole." Soon, nearby mines like the Copper Prince and Atlanta Mines were developed. The Copper Queen Consolidated Mining Company was created from mergers with other companies and began buying neighboring properties. The company focused on the southeast, looking for deeper mineralization, adding more mines to its growing business. In 1899, the competition arrived. Capt. Jim Hoatson returned to Calumet, Michigan, with samples of Bisbee ore and convinced his friends to buy the Irish Mag Claim. They formed the Calumet & Arizona Mining Company and struck it rich with the Irish Mag Mine. Within three years, it acquired all the remaining valuable properties to the southeast, leaving the Copper Queen landlocked. Underground mining dominated the district until 1917, when the Copper Queen boldly started the Sacramento Open Pit Mine.

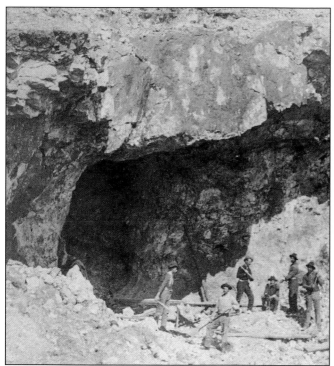

In 1880, with the development of the Copper Queen Mine, Bisbee made its first serious attempt to exploit the valuable mineral deposits. It began with a mass of oxidized copper and iron that was discovered on the north slope of Queen Hill. This created a cavernous opening known as the Glory Hole, extending below the earth 200 feet and producing 20 million pounds of copper.

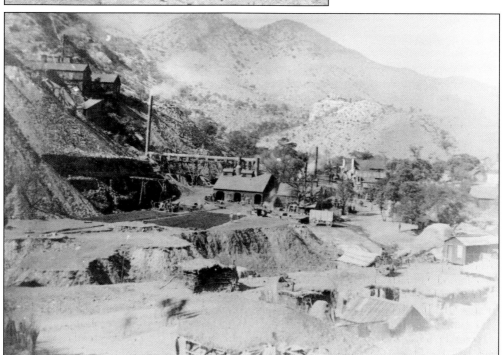

This photograph looks west toward the Copper Queen Mine and its early smelter. The isolated camp struggled to survive, subsisting on only extremely high-grade copper ore from the Copper Queen. By 1884 the camp was desperate, with only three months of ore left in the mine. Continual probing of the earth yielded nothing. (Courtesy of the BM&HM.)

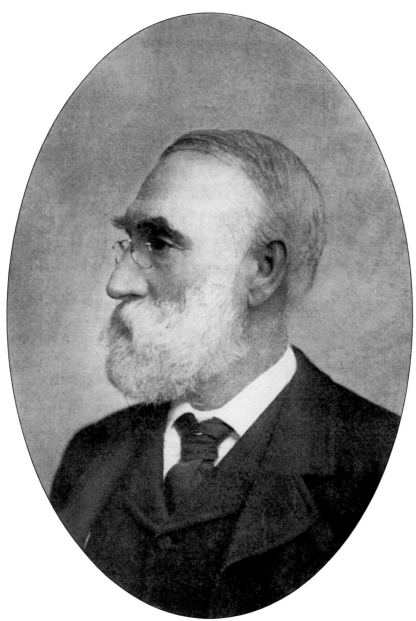

In 1881, news of the rich strike at Bisbee attracted investors. Phelps, Dodge & Company, a New York mercantile firm, sent Dr. James Douglas (pictured) to examine the Atlanta Claim, located next to Copper Queen Mine. A steep purchase price of $40,000 was being asked for the claim, but Douglas recommended the property, understanding the high risks and that the firm should be prepared to lose everything. Instead of payment for his work, Douglas received a share in the mine. The next two years were difficult; he spent $80,000 in unsuccessful exploration. A last-ditch effort was made in 1884, when Phelps, Dodge & Company allowed Douglas to spend a final $15,000 to sink the Atlanta Shaft. The shaft was developed to a depth of 400 feet; after reaching 210 feet, a massive ore body was struck. The Copper Queen Mine hit the identical ore body at the same time. To prevent lawsuits, the companies merged, creating the Copper Queen Consolidated Mining Company.

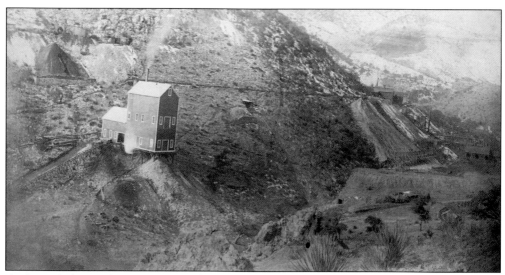

At the end of 1884, the next great ore deposit was found. It was located 600 feet east of the original deposit, deeply buried under barren limestone. With this discovery, the outdated Copper Queen Mine (right) was replaced with the modern, 440-foot-deep Czar Shaft (left) in 1885.

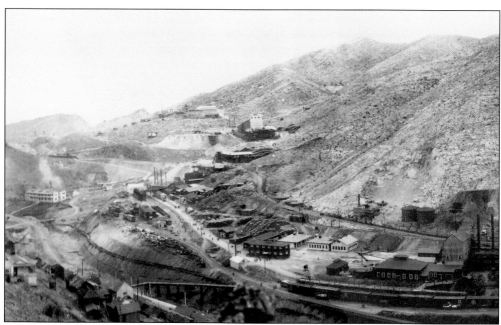

The new ore revitalized the camp. Investors were attracted, and several new mines were quickly developed. Exploration was pushed deeper into the earth and to the southeast. Soon, vast prices were being paid for any land with potential value. Quickly, all of the surrounding land was procured, valuable or not.

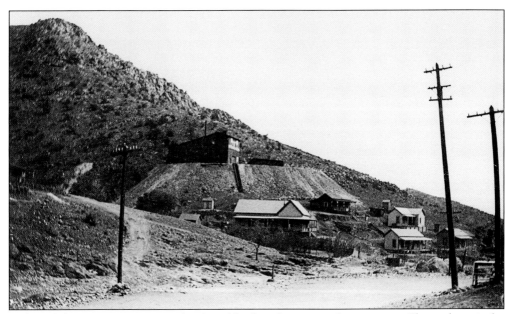

A few of these new mines were developed by less-than-scrupulous persons. Shown here is the Copper King Mine, which used its proximity to the Copper Queen to attract investors and soak them of their money. The Copper King was on the other side of the Dividend Fault, a geological boundary of minable ore.

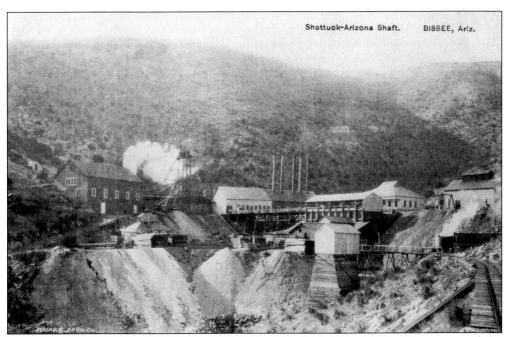

Shattuck-Arizona Shaft. BISBEE, Ariz.

The important arriving companies were the Shattuck & Arizona Mining Company and the Calumet & Arizona Mining Company. These successful companies surrounded the Copper Queen properties and limited the company's ability to expand and search for additional deposits of ore. The Shattuck Mine (pictured) was noted for its copper and gold production.

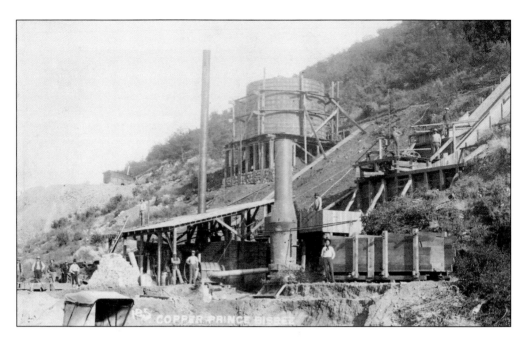

Smelters were needed to process the copper ore coming from the mines. In the furnaces, ore was heated, causing it to reduce into copper metal, which was poured into ingots. This process produced "black copper," which was impure and needed further refinement. Originally, the copper ore had to make an arduous journey to the West Coast via a 24-mule team. It was then sent by ship to Wales for final processing. In 1880, an influx of investor funds enabled the building of Bisbee's first effective smelter. The Copper Prince Smelter (above) was one of the earliest smelters in the camp. It only survived a short time, as changes in technology rendered it inadequate. Below, workers are weighing black copper ingots at the Copper Queen Smelter before shipment. This smelter would undergo several upgrades, operating until 1903.

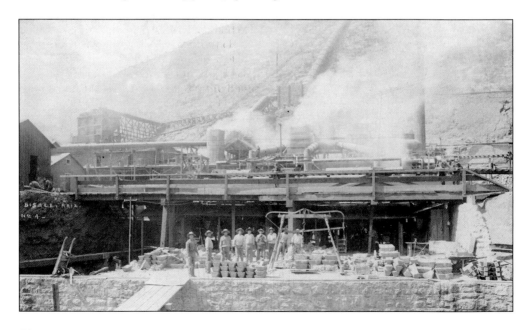

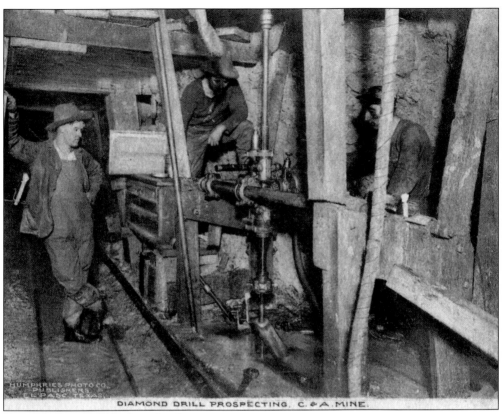

DIAMOND DRILL PROSPECTING. C. & A. MINE.

Locating ore was difficult in the district, because of the nature of the deposit and a lack of understanding of the geology. At this time, the only minable ores were found as scattered pockets of copper-bearing rocks inside the limestone. The initial method of locating the deposits was driving tunnels and sinking shafts under the guidance of the mine foreman, hoping to hit ore. When discovered, the miners were never sure if it would disappear with the next blast. This method was replaced by hiring geologists and using diamond drills. Recovered core samples of the rock enabled them to determine the location and shape of the mineral deposit. Samples were taken to ascertain if the rocks contained enough metal to offset the cost of mining.

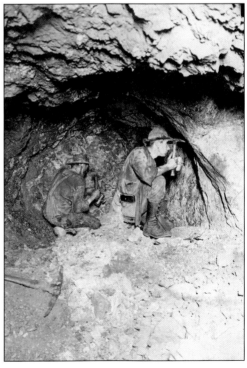

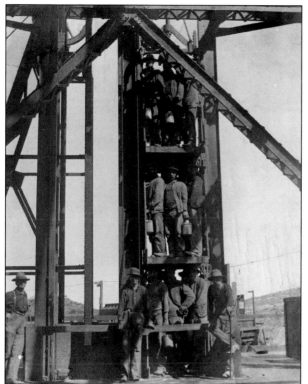

Shafts were sunk to provide access and ventilation to deeply buried ore. From these shafts, a labyrinth of tunnels spewed out. Quickly, hundreds of miles of these passages were blasted. At left, 27 men loaded into a three-deck cage are about to be lowered into the Gardner Mine. Below, the Spray Mine headframe is shown partway through construction. This mine used the eastern mining style, with a building surrounding the hoist and steel mine headframe. Hoisting works functioned as elevators, bringing men and supplies into the mine and the ore out. A massive double-drum hoist fed flat cables over the spoked, pulley-like wheels balanced on the top of the headframe, then down to the cages. The companies grew accustomed to Bisbee's climate; later, headframes were built in the open air. (Below, courtesy of the BM&HM.)

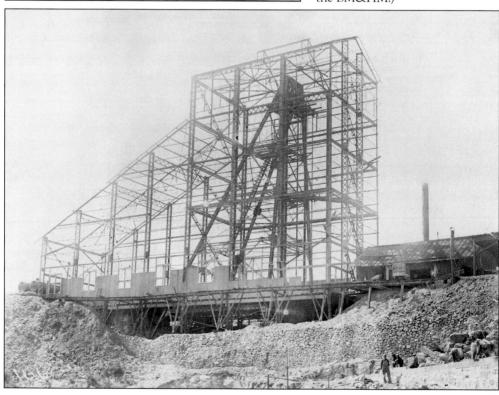

Once a pocket of ore was discovered, miners began to blast out the ore by carving great chambers, called stopes. Typically, after each blast, a "cube" of timber, called a square set, was built. These timber sets were interconnected, providing not only support for the ceiling and walls, but also serving as scaffolding. The excavation was normally done starting from the bottom, working upward and dropping the broken rock to the tunnel below. The stopes could reach enormous dimensions. After a determined number of sets had been installed, they were filled with waste rock, providing stronger support. This mining method required vast amounts of timber to be delivered underground. The photograph to the right shows a square set stope that is beginning to collapse. Shown below is the Junction Mine timber yard, which served the Calumet & Arizona mines.

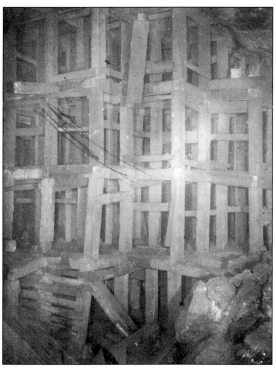

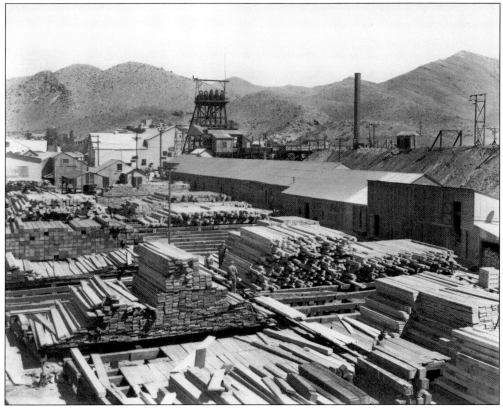

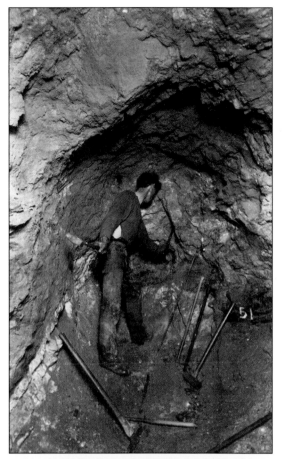

Tunnels were driven to access the stopes. These were drilled and then blasted out with dynamite. Originally, miners would have drilled the blast holes by striking a long chisel with a sledgehammer by only the flickering light of a candle. By 1903, pneumatic drills were becoming popular, and the rate of mining increased. A hole that would have taken the greater part of a shift to drill could now be drilled in a mere 15 minutes. Although still working under the illumination of candles, the new drills eased the burden of miners. For a few years, drills operated solely on compressed air. Dust created by drilling in quartz-bearing rock resulted in the miners suffering from silicosis. This dangerous piece of equipment became known as a "Widowmaker." Later, water was added to control the dust.

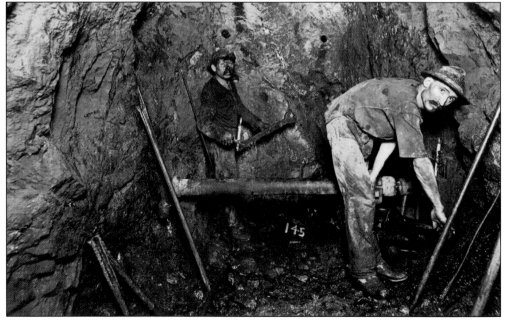

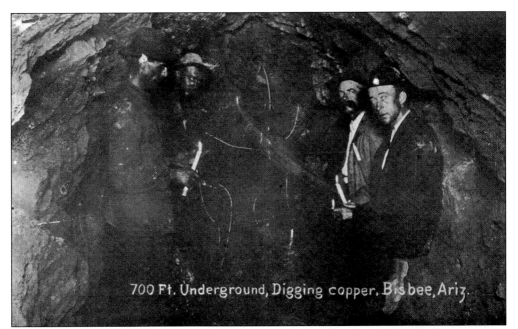

700 Ft. Underground, Digging copper, Bisbee, Ariz.

Underground mine workings were created by blasting, which was the responsibility of the miners. They learned the skill of the correct placement of dynamite in the drill holes and how to trim fuse to get a proper firing order. At designated blasting times, the miner would light his fuses and walk a safe distance, waiting for the detonation.

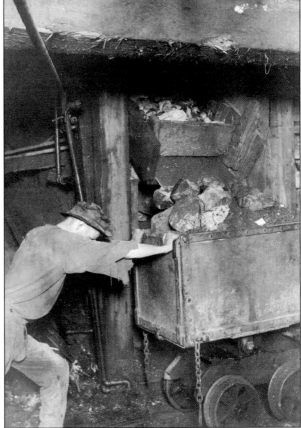

In the early years, the rock was removed by hand tramming. A man would be given the arduous task of pushing a mine car loaded with rock to the surface or a shaft. This method greatly hampered production and could be used for distances of only a few hundred feet, and for loads of only one ton at a time.

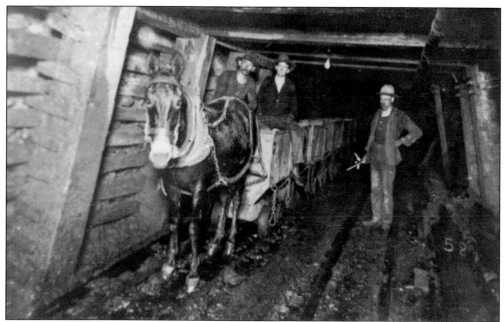

By 1902, the first mules were lowered underground to haul trains of broken rock. They could pull, on average, four to six loaded cars a distance of 15 miles per shift. Well loved, they were stabled in underground barns for years at a time. Although troublesome at times, they could be playful. One mule in the Holbrook Mine would walk up to a miner and gently place one of its hooves over the miner's boot, increasing the pressure ever so slowly, until the miner was in agonizing pain. Another mule practiced a similar trick. The mule would approach a miner, and, when the man was between the tunnel wall and its flank, the animal would slowly begin to lean on the man, until the miner felt like he was being crushed. (Above, courtesy of the BM&HM.)

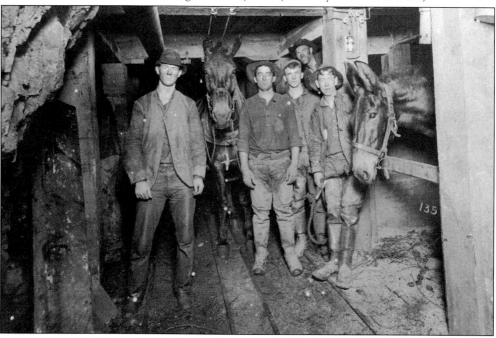

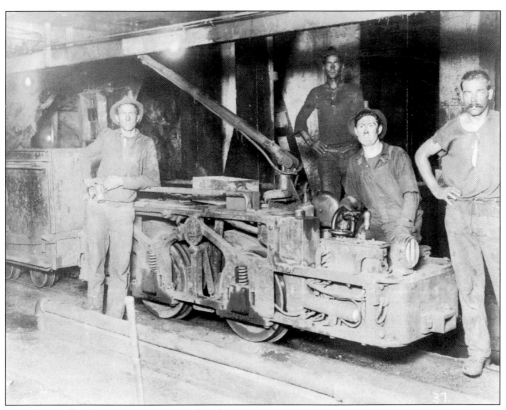

By 1908, trolley locomotives were utilized underground to pull the trains. These machines could pull up to 40 mine cars. Due to the great expense of enlarging the older tunnels to accommodate the locomotives, they were installed in only sections of the mines. These locomotives created a new danger, as the miners had to be constantly aware of the bare copper 250-volt trolley wire.

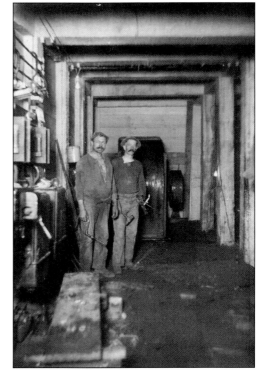

The introduction of electricity made vast improvements to the underground environment. The unfathomable darkness was now broken by occasional incandescent bulbs, replacing candles. Mechanized ventilation allowed fresh air to reach the most remote locations, dropping the temperatures, pulling the stale air to the surface, and pushing out the dust and smoke. Here, miners with candles stand in an electrically lit blower station.

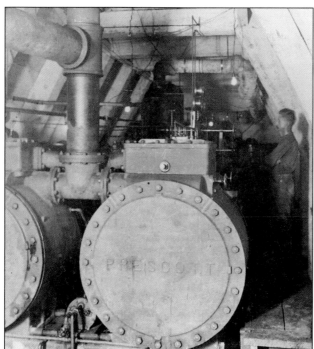

As mining increased in depth, volumes of water were struck. At the Briggs Shaft, men were working up to their waist under a downpour while deepening the shaft. Pumps like these at the 900-foot level Briggs pump station were installed to fight the inflow. This mine had to be shut down temporarily because of water.

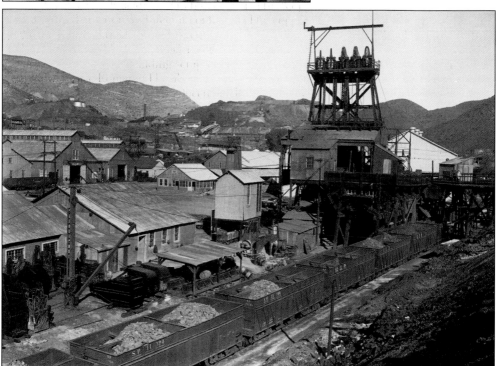

Innovative thinking on the part of the Calumet & Arizona engineers prompted the Junction Shaft to be converted into the primary pumping station. Tunnels were driven out to the other mines to drain the saturated ground. The Briggs Mine was rescued by this process. Later, some of the Copper Queen Mines were also drained through the Junction (pictured).

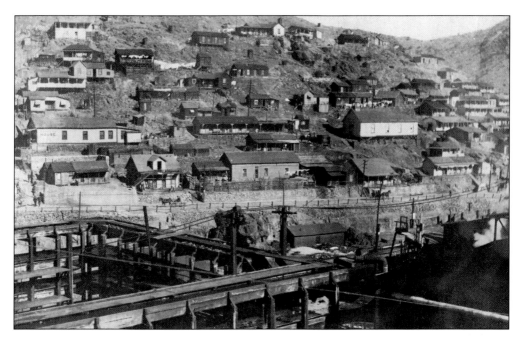

Copper-bearing acid water was another problem. As surface water seeped through the sulfide ores, it became highly acidic and rich in copper. This "copper water" caused sores on the workers and destroyed any iron and steel it contacted. The copper in the acidic water replaced the iron particles. Railroad tracks would be converted into a copper-iron sludge. In places, the rails had to be changed weekly. Companies recognized the value of this solution and pumped it through wooden pipes into vats, adding scrap iron to create copper mud. This ancient technique was developed by the Romans. The above photograph shows the corner of a vat located at the Czar Mine. At the abandoned Copper Queen Smelter site (below), the same vat can be seen as a hollow rectangle between the Czar Mine and a partially dismantled smelter stack.

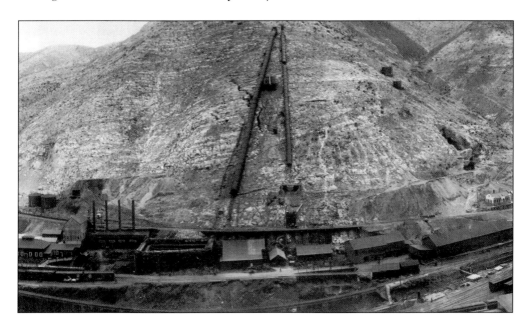

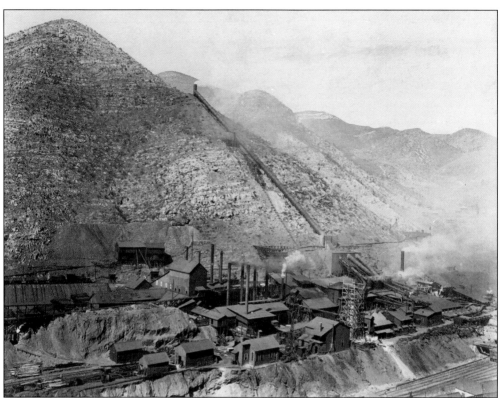

On June 24, 1904, the last of the smelters was closed in Bisbee. As shown above, it had an unusual system of stacks that followed the incline of the hillside, up to approximately the 5,700-foot elevation, where the stack turned vertical for a short distance. This allowed the sulfur-rich smoke that poured from the stack to escape the confines of the canyons. Only somewhat effective, the town was often smothered by clouds of smoke. This smelter was replaced by a modern smelter (below) located at Douglas, Arizona. The new location had abundant water and room for dumping the molten slag. It also was situated on flat land, allowing the smoke to dissipate.

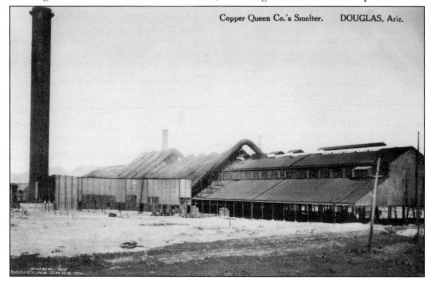

Copper Queen Co.'s Smelter. DOUGLAS, Ariz.

Danger was always present, so miners needed to be constantly aware of their surroundings. With the introduction of mechanized mining, underground workings were being opened at an ever-increasing rate. This situation, along with the aging of the mines, resulted in numerous collapses. Falling rocks were the primary cause of fatal accidents in Bisbee.

During 97 years of mining, more than 350 men were killed in accidents. In 1912, all mining companies developed safety programs to reduce accidents. This is a staged photograph of a mine car that had a pin break, resulting in the tub of the car falling, crushing a man. This photograph was part of the safety program enacted after a man had been killed in a similar accident.

Chris Vucedalich was killed here by a falling rock. This accident was located in a stope on the 1,600-foot level of the Sacramento Mine. Note that temporary repairs have been made to support the broken timber. After a tragedy, the coroner's jury would visit the site as part of their investigation.

New guys were always gullible to a ghost story. Typically, an experienced miner would describe a fatal accident that occurred nearby in gruesome detail; invariably, the man's apparition would wander the dark passages. The silence of a lonely tunnel could be broken by the eerie cracking and popping of timber or falling rocks.

Mine fires were a constant concern. The sulfur-bearing rocks ignited easily, and the fires were nearly impossible to extinguish and could burn for decades. Pyrite, or "fool's gold," and related minerals were problematic. Pyrite's name was derived from the Greek word *pyros* (fire). Spontaneous combustion, blasting, and timber fires were sources of ignition. Once a section of the mine was burning, it was sealed off. The companies would then attempt to mine near the burning areas. Fire gasses would at times escape into active workings, but these were controlled. Specially trained helmet crews (below) at the Junction Mine would be sent underground to seal off fire zones, rescue miners, and repair areas flooded by fire gasses. In the safety photograph to the right, two mine cars have been parked, preventing an automatic fire door from closing.

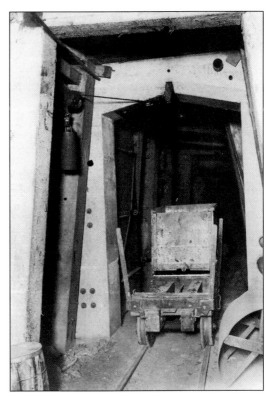

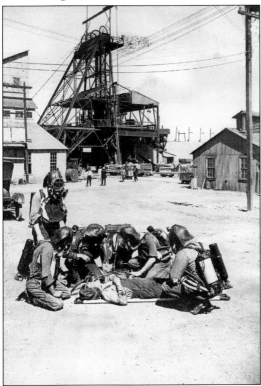

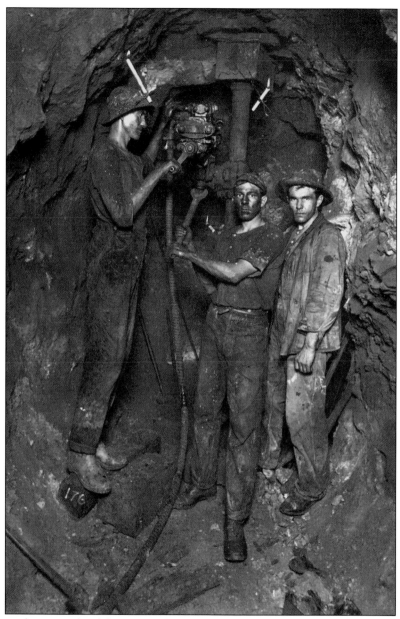

Miners were the pinnacle of the men underground. These were the rock-solid men who worked through the ranks and had gained the essential skills of blasting, drilling, timbering, and mucking. Miners were responsible for the advancement of the workings. There were other positions inside the mine, like timbermen, powdermen, and motormen. They supported the miners by repairing the mine, taking out the broken rock, and making sure the explosives were ready to use. In 1917, there were 25 different positions for the underground mines. Of course, some jobs, like mule shoers (farriers), employed a limited number of men. The lives of these men are largely recorded in oral histories. Interestingly, three common themes are revealed: they loved working underground, they felt safe, and they appreciated how the companies took care of their employees. In these early years, the companies kept older men employed into their 80s and gave them positions created solely for them. Some miners remarked that they felt safer underground than on the surface.

Powdermen had the responsibility of taking care of the explosive storage, or magazines. The different types of explosives had to be stored in separate magazines, one for blasting caps, and the other for dynamite. The powderman's job was to rotate the explosives, making sure the older stock was used first. He also crimped blasting caps on fuses and kept the magazines clean. (Courtesy of the BM&HM.)

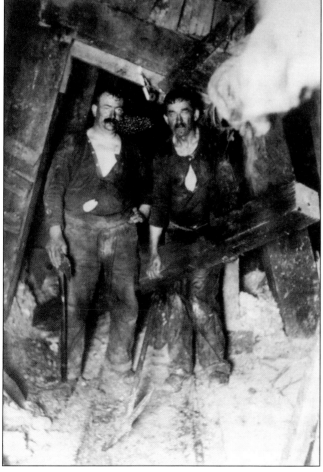

Timbermen did the difficult and dangerous work of replacing the mine timber after it rotted, broke, or was distorted from caving ground. In places, the timber had to be repaired every 24 hours. Steel and concrete supports were tested, but they proved unsuccessful. These timbermen, working in a collapsing area, are adding extra timber to keep the area open. (Courtesy of the BM&HM.)

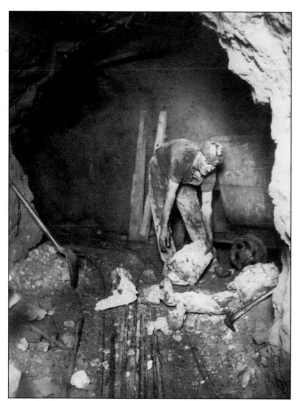

At the bottom rung were the muckers. These men cleaned track, dug water ditches, and shoveled the rock into mine cars. It was the most physically demanding job in the mine. This mucker is using an improper technique to load boulders into a mine car.

Joe Chisholm started underground at the Czar Mine as a tool nipper in 1887 at the age of 12. Young men were assigned light-duty work. Heavier jobs were given to the older men. This surface crew, which includes younger men, is seen at the Holbrook Mine. (Courtesy of the BM&HM.)

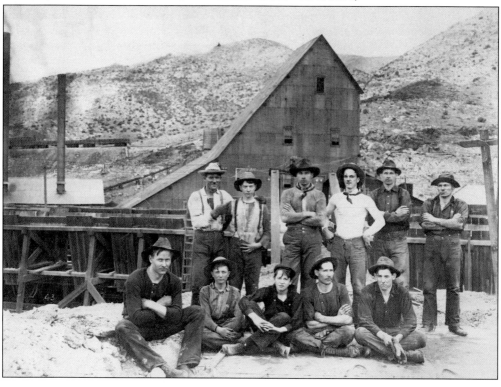

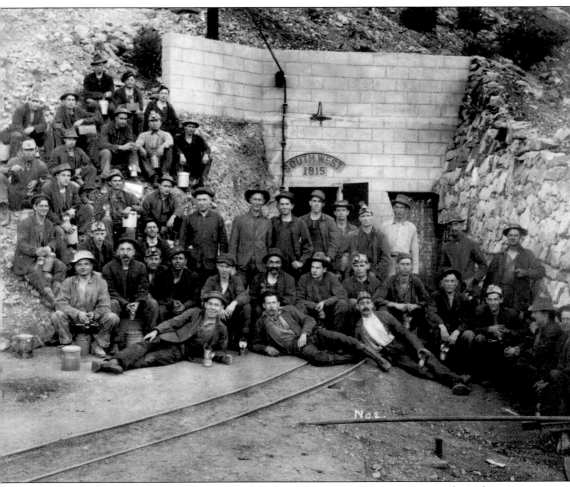

Underground workers pose in front of the fifth-level Southwest Mine entrance. The industrious men who worked here came from all over the world. The proud "Cousin Jacks" from the ancient tin mines at Cornwall, England, brought the highest level of mining skill. In addition, men from the Austro-Hungarian Empire, Manxmen from the Isle of Man, Finnish, Mexicans, and even an engineer from Japan worked the mines. The men, mostly single or with wives in the old country, often supported families back home. One brave young woman traveled from a Slavic country, crossed the Atlantic Ocean, and traveled by train to Bisbee to meet her husband. Unable to speak English, she traveled by the kindness of strangers, arriving with a note pinned to her clothing reading, "I am going to Bisbee, Ariz."

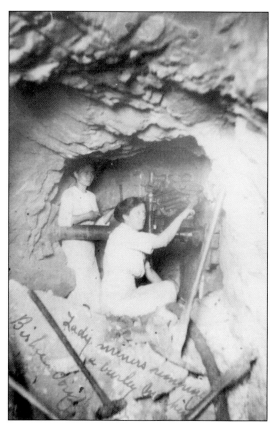

Visitors were not uncommon in the early underground mines. Bisbee was proud of and shared its industrial might. Tourists would spend hours climbing narrow passageways into massive timbered stopes to see the brilliantly colored, rich ores. Lucky guests would be able to gather samples of rocks and crystals. Often, a person would be given the special treat of viewing a crystal-lined natural cave struck by mining. Mule barns were favorites; visitors were astonished at the excellent care the mules received. Rats were introduced as the miners' companions. The mine rats were never intentionally harmed. The rodents recognized the miners' lunchtime and would anxiously await scraps of food. One woman described a rat that enjoyed warm candle wax being dripped onto its head. (Both, courtesy of the BM&HM.)

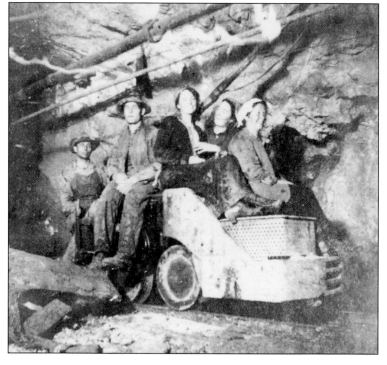

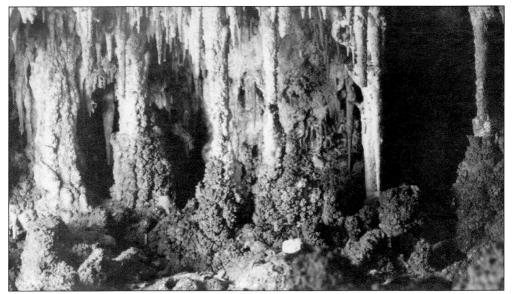

Natural caves were discovered near the ore in the mines. These were filled with vividly colored formations of reds, blues, greens, and translucent golden amber, caused by the copper and iron minerals. One of the caves in the Shattuck Mine was over 300 feet tall and 700 feet long.

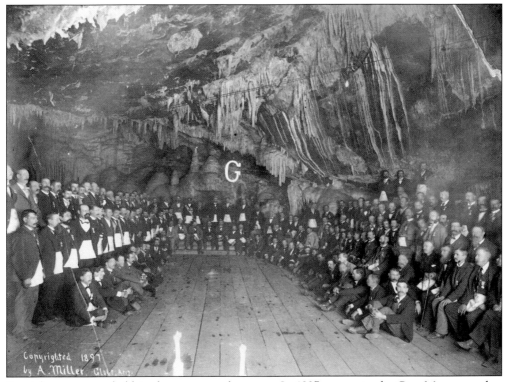

Copyrighted 1897
by A. Miller Globe, Ariz.

Special events were held in these spectacular caves. In 1897, a cave in the Czar Mine served as one of the most beautiful lodge rooms in Masonic history. The well-dressed attendees had to be dropped 200 feet down, and they then navigated 1,800 feet of winding, muddy passages to arrive at the illustrious chamber.

63

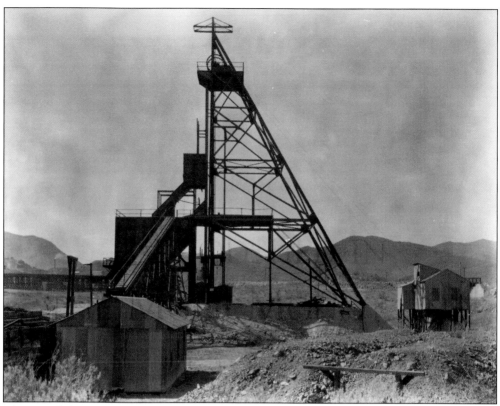

The Campbell Mine (above) was the last of the great underground mines to be developed. Sinking began in 1917, and it eventually reached a final depth of 3,333 feet. This mine would later discover Bisbee's largest ore body. In the years following World War I, development was slowed due to low copper prices. In 1917, a new era of mining began in Bisbee, with the opening of the Sacramento Open Pit Mine. It took over a decade to outline and study the low-grade deposit, but after it started, it foreshadowed not only the future of mining in Bisbee, but also in Arizona.

Three

BLOODSHED IN
THE MULE MOUNTAINS

Bisbee's cemetery is filled with the graves of those who found themselves at the wrong end of a barrel. Greed, self-preservation, and overwrought emotions drove Westerners to find solutions with a cold steel trigger. This type of resolution could rapidly end with a lawbreaker spending their years suffering at the Territorial Prison in Yuma, Arizona. That was arguably better than swinging from a frayed rope. Fear of Apaches scarred the first tenuous decade of the camp. Apaches both real and illusionary led to an armed populace and gave shadowy outlaws a convenient scapegoat.

The stage trip from Tombstone to Bisbee was a grueling and dangerous five-and-a-half-hour trip. On January 6, 1882, the stage included W.S. Waite as driver and Charles Bartholomew as messenger, along with one female and two male passengers. The stage ran into trouble after leaving Charleston and was pursued by five men on horseback. At Hereford, the messenger acquired a Winchester rifle, to be used with his shotgun in case there was more trouble. Then, eight miles from Bisbee, three men began firing at the stage, wounding a horse and hitting the coach. After a few miles, the stage was forced to stop because of the wounded horse. Bartholomew kept firing, keeping the bandits at a distance, but the stage was surrounded. The thieves told a Mexican wood hauler to tell the stage men that, if they did not hand over the Wells Fargo box, everyone would be killed. Passengers convinced the messenger to surrender. The robbers ransacked the Wells Fargo box and took $6,500, gold and silver coins, the mine payroll, and a horse.

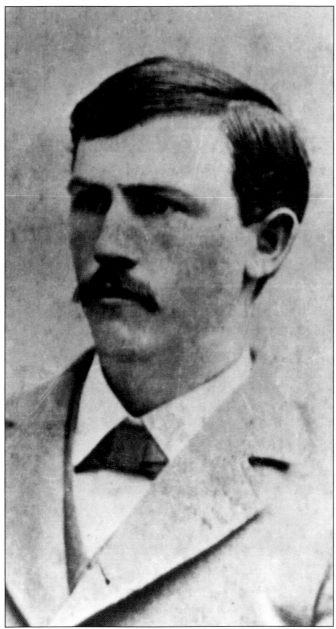

In Bisbee's infancy, the town did not have a bank. The Castaneda & Goldwater Store acted as such. To meet the demand of money needed to cash the miners' paychecks, a monthly shipment of $7,000 in gold coin was sent via stage to the store. On the evening of December 8, 1883, the dirt streets of Bisbee became stained with murderous blood, as the worst act of violence in the history of the town occurred. The store was approached by five gunmen, but the payroll had not yet arrived. The crime they were about to perform would be in vain. As three outlaws entered the business, the remaining two men stayed outside, guarding the entrance. Inside the establishment, the three men drew their weapons, intent on stealing the payroll. While the robbery was in progress, the other two desperados guarded the street. Soon, John Tappeiner (pictured) would become a victim of the bandits. (Courtesy of the BM&HM.)

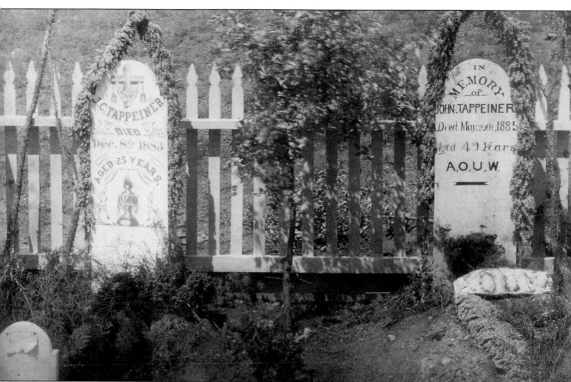

Mine assayer John Tappeiner exited a saloon, and a bandit ordered him to return to the bar. He refused. This was responded to with bullets, one fatally penetrating Tappeiner's head. His lifeless body fell across the threshold of the Bon Ton Saloon. Hearing the gunshots, people rushed to the streets, at which point the gunmen began shooting indiscriminately up and down the street. Curiously, an expectant mother, Annie Roberts, partially opened the door to her restaurant. She became another victim, as a bullet struck her. Deputy Sheriff William Daniels heard a shot and retrieved his weapon. When he emerged on Main Street, the bandits were commencing their getaway. Daniels futilely shot at the outlaws as they ran down the street. The unsuccessful robbery was said to have taken a total of five minutes. While Bisbee residents mourned the loss of the men who were gunned down, the death of pregnant Roberts caused the citizens to be filled with bloodthirsty revenge. (Courtesy of the BM&HM.)

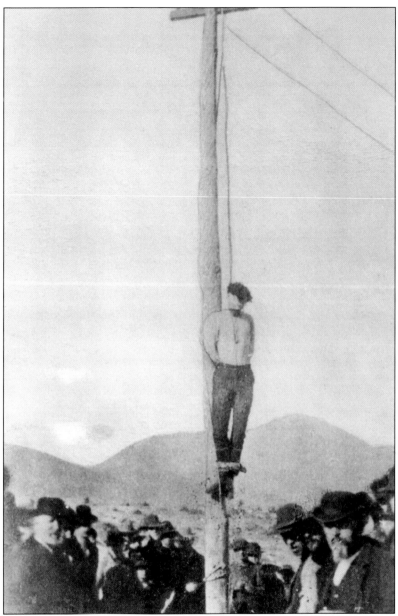

During the investigation, it was learned that John Heith was an associate of the murderous gunmen and had intentionally misled the tracking posse in hopes of throwing Daniels off the bandits' trail. Learning this, Daniels arrested Heith. By January 1884, all of the bandits were jailed in Tombstone. Heith was tried in court separately; the other outlaws were tried together. The five Bisbee robbers were found guilty of first-degree murder and sentenced to hanging. Heith was found guilty of second-degree murder and was sentenced to life imprisonment. Citizens were enraged with this decision, and a vigilante group was formed to correct this perceived injustice. On February 22, 1884, the Bisbee mob of 100 unmasked men approached the Tombstone jail and removed Heith. He was taken to a telegraph pole on Toughnut Street. Heith asked the crowd to not riddle his body with bullet holes and proclaimed his innocence. He pulled a handkerchief from his pocket, tied it over his eyes, and the mob lynched him.

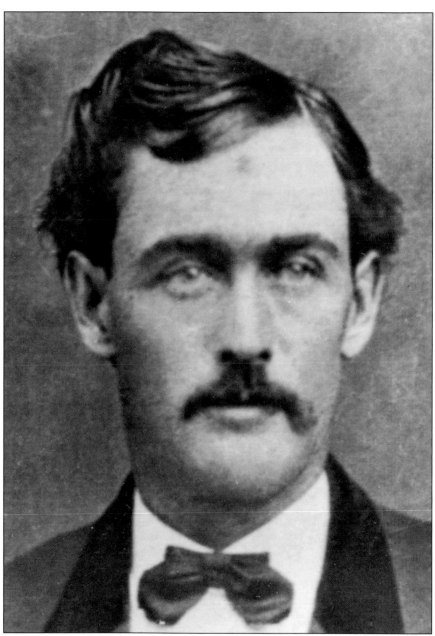

In the mid-1880s, the Mule Mountains were still exposed to the threats of Apache crime and violence. Newspapers state that Deputy William Daniels came West to kill Apaches, but the noted deputy and popular saloon owner met his end at the hands of Native Americans. Daniels followed up on a lead of killed livestock; Indian trails led from Forrest Ranch into Bisbee's Mule Mountains. After miles of tracking with two men, Daniels was confident he knew the Apaches were camped near Bisbee and decided to go back to get an armed group of men. However, without knowing, Apache scouts had been following them. They shot at Daniels, striking his horse. The animal fell to the ground, breaking its neck. Reportedly, Daniels broke his neck, too, in the fall. His companions emptied their firearms and safely escaped. For Daniels, there was no escaping the fate before him. (Courtesy of the BM&HM.)

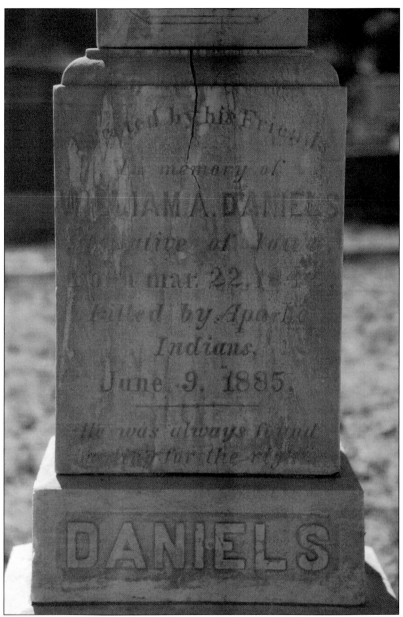

The Apaches shot Daniels in the head seven times, then, using a rifle butt, bashed in his head and jawbone. One of Cochise County's legendary lawmen was now gone. His murderers stole many of his possessions, including his coat, saddle, and bridle. When Daniels's companions finally reached the scene, they raced to the location, scared off the Indians, and retrieved the battered remains of the fallen officer. Reports later determined that Daniels had been tracking 70–80 Apaches, who had in their possession 150 horses. Residents of the area were full of fright and fled to places of safety as the San Jose and Mule Mountains were claimed to be full of Indians. Daniels was laid to rest the following day at the Brewery Gulch Cemetery. He was buried beside Bisbee Massacre victim John Tappeiner, whose murderers Daniels had pursued two years earlier. Daniels received an honorable burial service; the funeral was very large, with almost everyone in town attending.

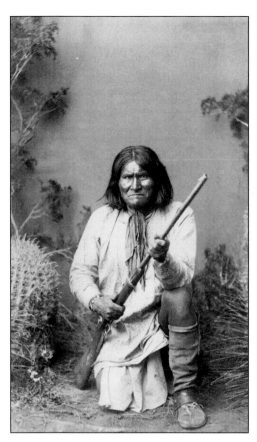

After the killing of Daniels in the Mule Mountains and the murders of others throughout Cochise County, on October 6, 1885, county leaders unanimously adopted a resolution pertaining to "the matter for reward for hostile Indians." This authorized the sheriff of Cochise County to offer a reward of $500 for the apprehension (dead or alive) of Geronimo and a reward of $250 for any of the "band of [his] renegade Indians, who were engaged with him in his murderous raids throughout the County." In August 1886, seeing no other solution for the fate of his people, Geronimo (pictured here) made his final surrender at Skeleton Canyon, about 70 miles from Bisbee. (Left, courtesy of Library of Congress.)

Four

FLAVOR OF WHISKEY
AND A FULL HOUSE

Miners worked seemingly endless hours in the utter blackness and danger of the mines. To relieve this arduous existence, many men sought solace in a bottle to dull the jagged edge of life. Others sought and found the feminine charms of a lady of the scarlet profession. Still others found a few moments of satisfaction behind a hand of cards. After work, the miners wandered home along roads lined with enticements. The narrow canyons trapped the savory smells and sounds of tinkling glasses, and the sounds of jubilant piano music from saloons echoed down the dusty streets. A man was faced with the devil's choice: climb to a bare, wooden home perched upon a canyon wall, or succumb to the temptations.

By 1880, the fledgling town already had four saloons and a brewery. The camp grew rapidly; within a few years, the Copper Queen Mine employed 600 men. These men were the highest-paid miners in the West. Most of them were single; confined to the remote camp, they spent their money freely, exchanging it for one of the vices abundantly sold. The Copper Queen attempted to restrain its employees, stating that workers found drunk or gambling would be fired. The rules made it clear that drinking was permitted as long as the man was not indulging to intoxication. Yet, these taverns prospered. They varied in style and in the patrons that they served. Some, like the Annex, Office, and Orient Saloons, were elaborately decorated and refined. Many, but not all, offered gambling and/or billiards. Each saloon had its own attractions. The Azurite and other saloons displayed unusual relics, such as a rope that belonged to Geronimo, collections of curious weapons, and cases filled with beautiful samples of crystalline ores from the mines. Others offered lunch counters, dining, or specialized betting on events of local taste, like hard-rock drilling contests and regional sporting events. Other saloons, like the Butte, Turf, and Little Casino, catered to a rougher crowd, evident by the frequent arrests and bloodstains on the floors.

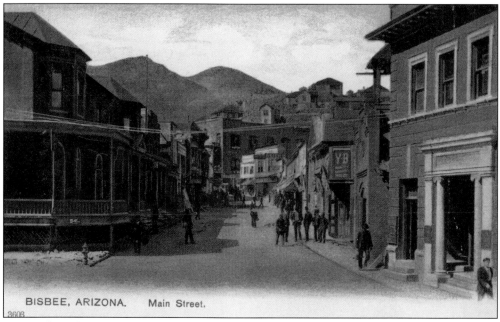

BISBEE, ARIZONA. Main Street.

Originally, Bisbee was divided into two saloon districts. District One was located up Main Street as far as Castle Rock, and District Two extended from the mouth of Brewery Gulch, through the Red-Light District, until it reached the city limits. These districts were established to prevent the roaring music and the brawling in saloons from being introduced to the residential areas. Saloons at this time were open a continuous 24 hours, and these streets were known to be livelier at midnight than at noon. Respectable establishments were often used as meeting places and for business transactions. In 1907, Arizona began regulating saloons, passing legislation restricting women from entering drinking establishments.

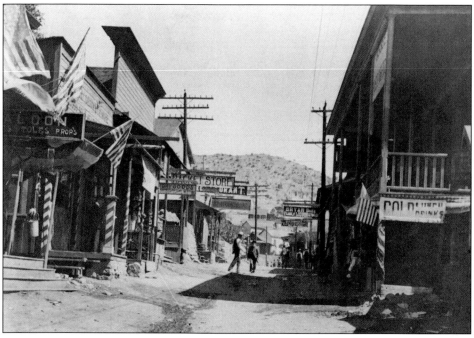

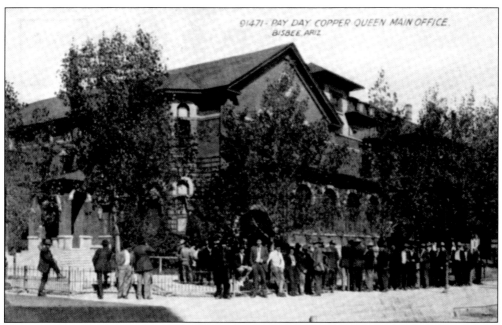

On payday, men lined up at the Copper Queen Consolidated Mining Company's office to receive their wages. Miners received $96 in gold and silver for a month's work. On paydays, the saloons were accordingly busy; a man could wait hours before a poker or faro table was available. It was said that, at the Orient or Turf saloons, a man could "die of thirst" before he was served.

The Orient opened on March 11, 1902. It was considered one of the finest drinking establishments in the territory. As indicated by its name, it was decorated in an elaborate oriental motif, with a carved, 24-foot bar. The establishment also had three arched mirrors and the word "Orient" displayed in tiny electric lights. The saloon was illuminated by over 400 lights, many of which were colored.

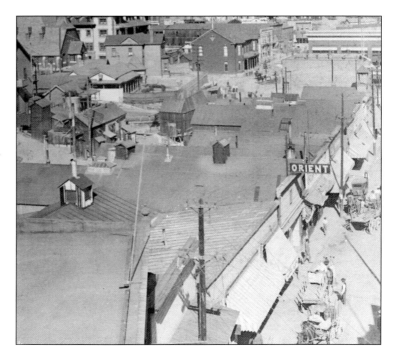

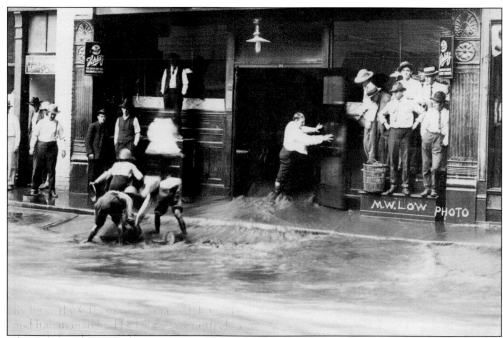

If a saloon was in business for any length of time, six-shooters were bound to be drawn, even in those that relied on quieter trade. The Turf Saloon attracted the attention of newspapers as a scene of violence, such as when George Boyd was shot down and left lying in a pool of blood behind a card table with a handful of red and white chips. In another incident, a drunk miner struck another miner with his lunch box, and out came several sticks of dynamite. This disagreement rapidly cleared the establishment. Above, floodwater rushes out the front doors of the Turf. Children are gathering items that have been washed out of the establishment. Below, men stand in the doorway of the Turf Saloon.

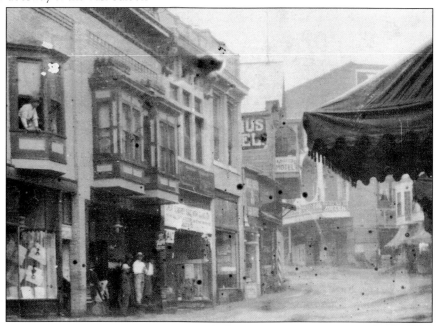

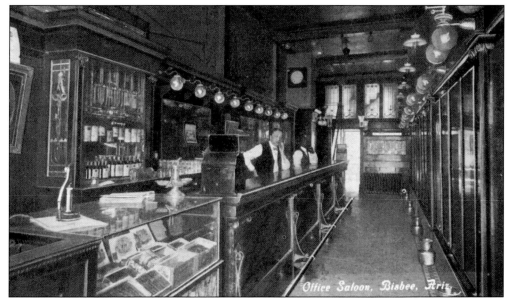

In 1906, the Office Saloon opened. It was considered palatial, with a quarter-sawn oak barroom and Italian marble. The lights were both electric and gas, and many of them were installed behind stained glass. Upstairs, the lounge and writing room were equipped with fashionable Mission-style furniture. For the first two hours after it opened, only ladies and their escorts were allowed, and drinks were not served.

Bartenders were popular and firm. More than one found trouble and was forced to knock an overindulgent customer with a pistol that they kept handy. Every year, the saloonkeepers contributed a nickel for each stray dog and bought them a license. The renowned Spud Murphy walked through the gulch with a collar reading, "I am Spud Murphy Feed Me." (Courtesy of the BM&HM.)

Gila monsters and Rattlesnake

Charles Hall, owner of the Bank Exchange Saloon, was also a taxidermist who used his work to attract customers to his business. His collection included the largest rattlesnake that had been found in Arizona, Gila monsters, and a rabid skunk, among dozens of birds and other exotic creatures. He proudly claimed to have the largest collection of birds and animals on display. (Courtesy of the BM&HM.)

To attract customers, establishments like the Azurite Saloon kept cases filled with beautiful crystalline minerals from local mines. Miners would bring specimens in, trading them for drinks or selling them to tavern owners. Many saloons built fabulous collections of glittering blue azurite, velvety green malachite, and brilliant blood-red cuprite. Shown here is calcite with aragonite from the Czar Mine.

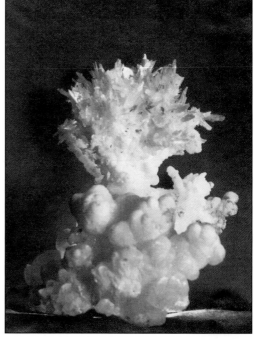

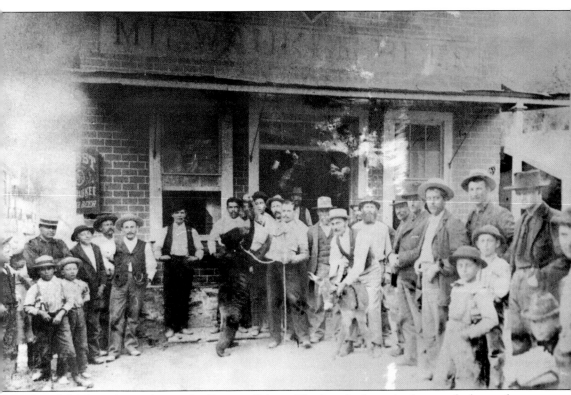

Joseph Muheim kept a bear in his Brewery Saloon. The bear had acquired a taste for beer; when it was intoxicated, the animal would spoil for trouble. He would hit a miner with a paw, and the miner would punch him back. The powerful bear could knock a man the entire length of the bar. This battle continued until the 300-pound bear or the miner tired out, and they would finish the evening drinking together. Fortunately, the bear was never known to bite or claw anyone. It just gave a powerful smack with the soft part of its palm. Muheim became concerned about the safety of keeping the bear after it forcefully took a bag of candy from a young girl. Soon after this episode, the bear accidently strangled itself with its leash. Intoxicated, the animal had climbed into a tree to sleep and fell out, getting caught on the chain. (Courtesy of the BM&HM.)

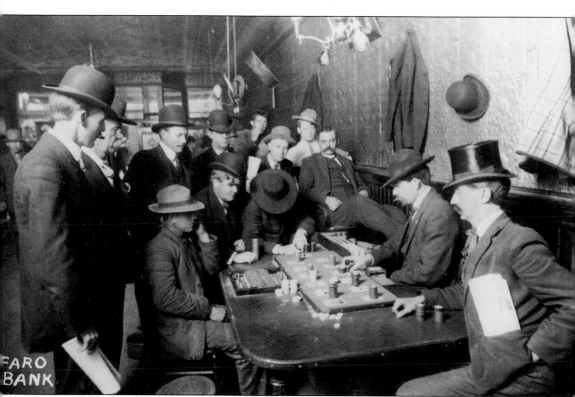

FARO
BANK

Gambling was a major attraction in many saloons. Roulette, poker, and faro were popular. Here, faro is being played in the Orient Saloon. This serious endeavor often resulted in conflict, although in unexpected ways. In 1903, Andy Howard staked James Quinn $50 to play poker on his behalf. Afterward, it was revealed that Quinn had played faro instead of poker and lost. Howard had Quinn arrested for grand larceny in the Orient Saloon and released on $750 bail. Early one morning in 1905, a stranger was playing faro at the Orient, betting $20 a shot. He was holding his own and left for a drink. Upon returning, he threw a crumpled bill on the table and continued to play. Soon, a stunned Tony Downs, an owner of the saloon, was handing the lucky stranger $500 in glittering gold pieces. Gambling was the first of the Western vices to disappear; it was outlawed in 1907.

Some establishments, like the Annex Saloon, attracted patrons who favored gambling on events of local interest, such as double jack drilling. This event celebrated the skill of drilling blast holes underground. A man would hold a steel with a chisel end, and another man would strike it with an eight-pound hammer. This would continue for 15 minutes; a champion driller could pound the steel 130 times a minute. Examples of this process are pictured here. Betting on these events was heavy and often reached ridiculous sums. In the 1903 contest, Con Shea, owner of house No. 9 in the Red-Light District, bet $500 on the team of Ross and Malley. His team lost to the newly formed team of Chamberlain and Make. (Both, courtesy of the BM&HM.)

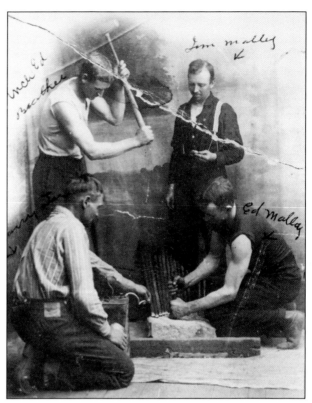

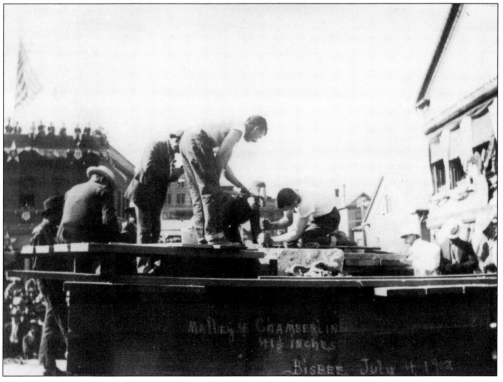

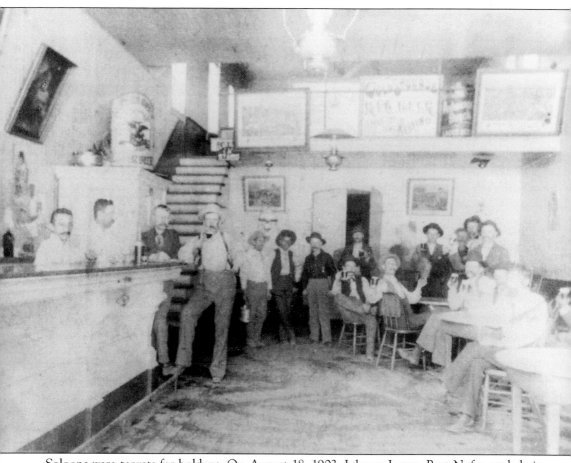

Saloons were targets for holdups. On August 18, 1903, Johnny James, Bert Noftz, and their accomplice, a lady of the Red-Light District, Mabel Carlise, held up the Beer Hall. James and Noftz entered the saloon and ordered everyone to put their hands up. As the roulette dealer, L.O. Milless, raised his hands, one of the robbers shot him three times. Then, as he stepped around the bar, Ed "Dutch" Schmidt, the bartender, was shot through his legs by the other bandit. Faro dealer Tom Wilson drew his six-shooter and began firing at the thieves, who quickly fled without any money. Noftz and Carlise temporarily escaped by heading to Cananea, Mexico, but James was quickly captured. James was tricked to going into the Red-Light District and confessed the crime to a housemistress, Mildred Ray. Harry Jennings, a law-enforcement officer, was hidden within hearing distance. Ray's testimony was deemed inadmissible at the trial. (Courtesy of the BM&HM.)

As Lowell grew, saloons became an important addition. But, as in other parts of Bisbee, conflicts arose quickly. One night, Jim English entered the Junction Saloon and found his son-in-law sleeping on a table. English carefully fired two shots at him. The shots landed on either side of the man's head, and he kept sleeping. After his arrest, English said he regretted not using a shotgun.

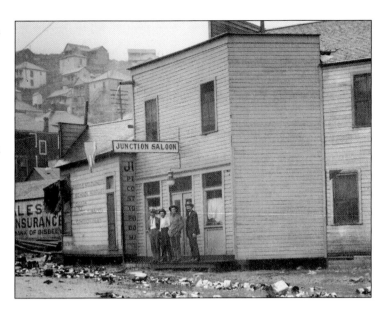

The decline of the saloons began in 1910. They were required to close from 1:00 a.m. until 6:00 a.m., and all liquor-serving establishments were closed in the Red-Light District. Prohibition stormed into Arizona five years before it was enacted in the rest of the nation. To survive, unruly saloons like the Butte, Hermitage, and Saint Elmo (pictured) were converted into family-oriented soft-drink emporiums. (Courtesy of the BM&HM.)

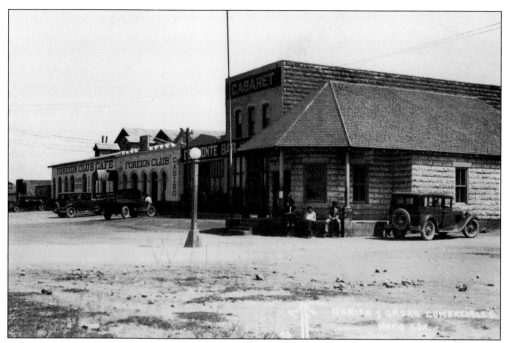

At the end of legal gambling in Arizona, the town of Naco, Mexico, was advertised as the future "Monte Carlo." Although this was never realized, gambling establishments did take hold. Due to Bisbee's location and advances in transportation, Prohibition was not very effective. Mexico, with its strong whiskey and dark-eyed beauties, was just minutes away. Saloons and gambling establishments began to thrive in nearby Naco. They offered a wild time south of the border, gambling, and, to a lesser degree, a red-light district. Only the displeasure of ending up inside a Mexican jail dampened spirits. Unlike today, crossing the border was simple, and Bisbee's residents regularly traveled into Mexico. Men headed to the mining community of Cananea, which had strong ties to Bisbee.

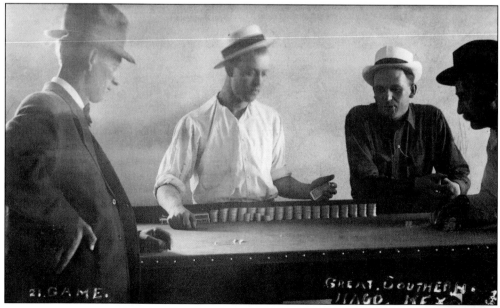

Five

WHISPERS OF THE UNDERWORLD

By 1880, a growing population of women of the scarlet profession had arrived. The charming Irish Mag was one of the earliest of the painted ladies to market herself in Bisbee. Although her occupation was less than dignified, Irish Mag earned a certain level of respect from the local men. Virtuous women often held an unexplainable higher level of allure and attraction. Numerous other women journeyed to Bisbee, some to find themselves coddled with champagne and diamonds. Still others found hardship and despair. Regardless, they led colorful and passionate lives. These flowers of the district used intriguing professional names to entice customers, such as Lily Silver, Trixy Fawcett, and Maryland Stewart. Quickly, these fictitious names became their true identities, appearing on court documents, newspapers, and even on death records. Their real identities were deliberately cloaked in mystery to prevent anyone from determining their pasts. Few of these women remained in Bisbee their entire lives. Those wilted flowers who did were buried in unmarked graves, leaving their families forever wondering.

In 1892, an official Red-Light District was created. The boundaries were north of Main Street and west of OK Street, and it occupied an area 1,200 feet from any public buildings, such as schools. Conflicts and crimes in the Red-Light District filled the courts of the justice of the peace. The district, with its dance halls, scantily clad girls, and saloons, was far wilder than other sections of the saloon districts. Eventually, nearly 100 girls were working in about 20 houses. Residents of Bisbee knew that if the Red-Light District was abolished, it would simply reopen beyond the city limits, and thus, beyond any control. This situation would be unacceptable. Ultimately, restrictions were placed on the district. On April 1, 1910, the dance halls were closed, and sales of liquor in the district were prohibited. Scarlet ladies were often dependent on money they made from dancing with the men and from selling exorbitantly priced drinks. The glowing red lights of upper Brewery Gulch dimmed a little after this, but they continued to burn. Even without the free-flowing alcohol, the Red-Light District remained dangerously wild.

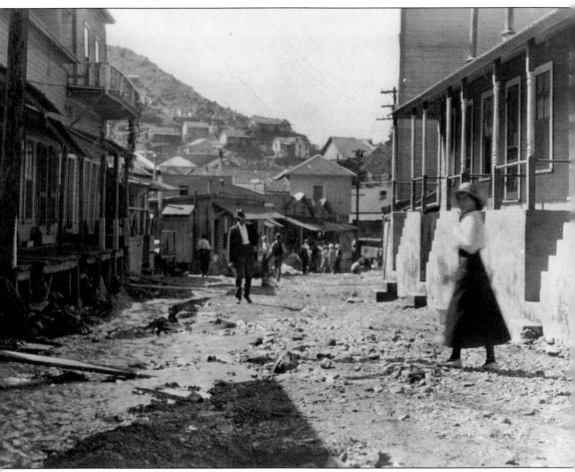

This c. 1905 photograph reflects the humble daytime nature of the Red-Light District. Formed in 1892, it was located in Upper Brewery Gulch and was lined with houses of immorality. The tainted history of the denizens of the quarter is only known through reports of dramatic events, tragedies, and men's perceptions. Time has shrouded the ladies' viewpoints. The district was an accepted part of Bisbee, and no strong local opposition was mustered against it. Interestingly, part of the recorded history is told by boys who delivered newspapers and groceries in the area. The buildings on the left used simple planks as bridges across the ever-present stream. On the right, the houses' individual concrete staircases lead to each apartment from the rubble-strewn gulch. As the sun retired behind the mountains, this section of town filled with music and the hollering of intoxicated guests. (Courtesy of the BM&HM.)

Central School is situated near the Copper Queen Hotel in downtown Bisbee. The present building, constructed in 1905, was erected over an earlier one-room schoolhouse. Its location was problematic for the ladies of the Red-Light District. Arizona's law restricted tenderloin district houses from operating within 1,200 feet of any school. As a result, legal houses of the district were built right up to the limit.

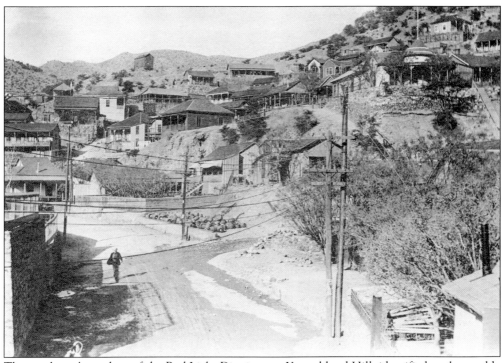

The southern boundary of the Red-Light District was Youngblood Hill, identified as the muddy road turning off to the right in this photograph. Generally, the scarlet houses and dance halls were built along the gulch. Higher on the hill are residential dwellings, where even families of affluence lived in close proximity to the ill-famed district. No woman of virtue would ever walk up this street beyond this point.

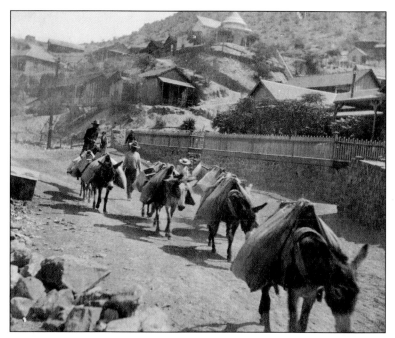

Seen at the top of this photograph is the family home of Joseph Muheim, a wealthy local businessman. The striking mixture of income in the residential area is evident here. Muheim was financially better off than most people in Bisbee, yet his home was surrounded by those of common miners. His children had a clear view into the Red-Light District below.

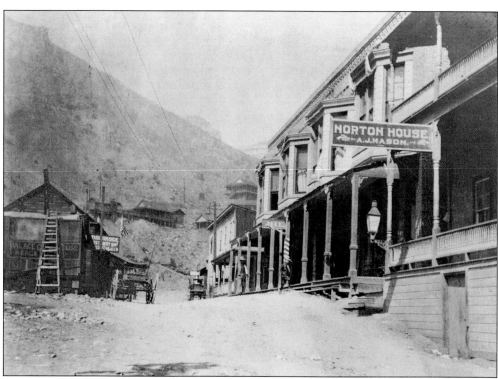

The district's legal boundaries were regularly being challenged. In 1906, four women were arrested in the Norton House (pictured), located on Main Street, for running a house of questionable distinction. On another occasion, women were arrested on Main Street above the Butte Saloon. The scantily clad ladies had been provocatively calling to customers on the street below, agitating citizens.

Incidents in the Red-Light District kept the justice courts busy. Normally, infractions were minor in nature, including ladies stealing from customers or disagreements between women of the profession. At times, disagreements became fierce, as when Ruby Davis stabbed a man, or when James Fagan shot up a couple of houses, perforating the walls and furniture. Another war in the district involved Tempest Wyland, Dora Tyson, and Marie Happe. The judge declared an armistice by placing two of the ladies under a $500 bond for six months of good behavior. After the hearing, the *Bisbee Daily Review* reported, "only the perfume of a dozen different attars remain in the court rooms as a reminder of the red-light war." Another case flaunted "a parade of the painted denizens of the underworld and two or three of them of the chocolate shade, most of them together with a number of male hangers-on. There was a dozen or more witnesses in each case and to the casual spectator the courtroom . . . presented the appearance of a tenderloin convention."

TENDERLOIN BATTLE RAGES THREE HOURS

List of Casualties is Headed by Piano Mortally Wounded

The Majestic, a resort in the reservation, was the scene of a three hour battle early yesterday morning, in which bottles, glasses and fists were used, to the detriment of heads and furniture. The fight, which raged with varying intensity, followed a night of post-pay-day revelry. It began about four o'clock, and the din of battle did not die until the limpid light of seven o'clock in the morning lit up the ghastly, glass-strewn battleground.

With the exception of black eyes, red noses, green snakes and brown tastes, no damage was done to the participants, including Amazons of the underworld, silk-socked hangers on and invaders of the reservation. The fight was as local as the battle of Agua Prieta or the siege of Naco, and reports of the fight did not reach the police until after the empty-bottle ammunition gave out and the fighting ceased.

A piano that had been rented was ruined by a flood of broken glass and wine, and the owner compelled the renter to purchase it outright, it being fit for nothing but Turkey Trot rags. No arrests have been made as yet, but the fight is being investigated.

This March 13, 1912, *Bisbee Daily Review* article describes an incident in the Red-Light District typical of the time. It refers to an ill-famed house as a "resort" and the district itself as the "reservation." The ladies themselves are called "Amazons." Interestingly, the article sarcastically compares the incident to conflicts from the Mexican Revolution that occurred only a few miles from Bisbee. Days later, two disreputable ladies, Mae Scott and Molly Jensen, were arrested, but the tension among the women remained high, and the community prepared for the renewal of a battle. In another incident, three men, intoxicated from "the bowl that cheers," threw a stray dog through a window of a house of the tenderloin. The occupants apparently failed to appreciate the "social addition" to their party. Unfortunately, one of the jokesters failed to escape quickly enough and suffered injuries. A physician had to be summoned.

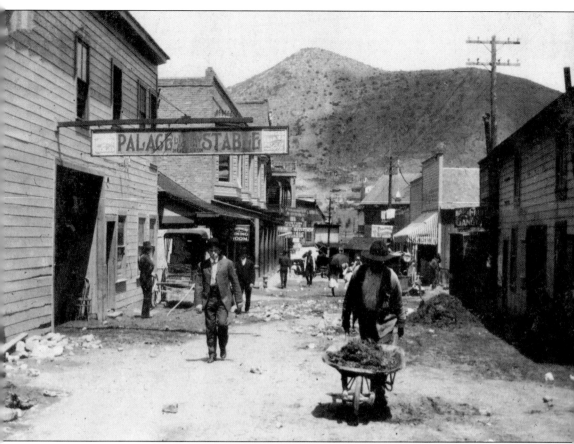

The tempestuous ladies of the Red-Light District aggravated the citizens by flaunting themselves and crazily racing up Naco Road on rented horses. Ed Fletcher, a stable owner, saw a drunk "woman of the houses" run a rented horse into a barbed-wire fence. As he tried to rescue the injured animal, the irrational woman attacked him violently. These wild rides continued, even after Ada Beaumont, a lady of the tenderloin, was mortally injured when she was thrown by a horse. The newspaper reported that she was the "wayward daughter" of a wealthy family. Some of her fellow fallen ladies collected money to send the penniless woman home to Kentucky, to be cared for by her family in her last days. Others went through her belongings, "destroying every trinket or piece of wearing apparel which might give to mother an inkling of the life her wayward daughter has lead."

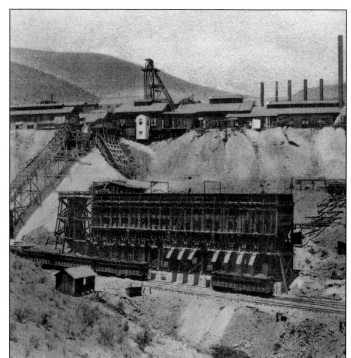

A miner could conceive of no higher honor than to name a mine after Irish Mag, who was arguably the first fallen woman in the camp. For decades, the steel latticework headframe and massive ore bins stood majestically on a hilltop above the rest of the mines. The riches it held beneath the ground were legendary, including a cavern lined with sparkling, crimson-colored cuprite crystals.

This sketch reveals the Bisbee that the little, dark-haired Irish Mag would have known. Although she may have lacked some virtues, she was filled with compassion and caringly tended to Deputy William Daniels after he had been killed by Apaches. She lived with a talkative parrot in a green-roofed house on the west end of town. The bird was kept outside, and passing miners taught it colorful vocabulary.

A coy girl attracts customers on Sixth Street in nearby Douglas, Arizona. Women of the Red-Light District frequently migrated to other such districts. The Red-Light District of Bisbee had strong ties to those in Douglas, Arizona, and El Paso, Texas. Often, the women would return to Bisbee to improve their business or visit old haunts and friends.

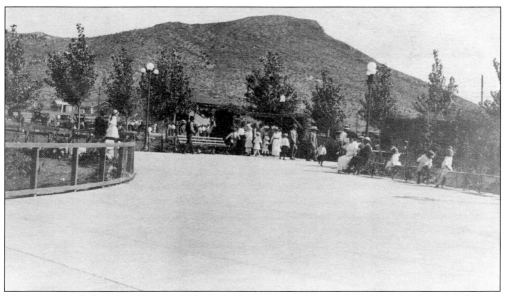

Warren, coined the "City Beautiful," had regulations protecting it from having saloons and a red-light district. A clause in the property deeds stated that the land could not at "any time be used for the sale of intoxicating liquors in any form, nor for gambling places or houses of ill-fame."

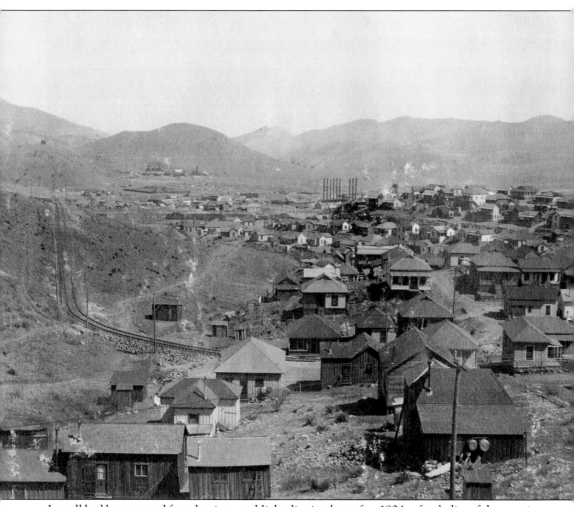

Lowell had been spared from having a red-light district, but, after 1904, a few ladies of the evening chose to move to the community. At the time, Lowell was considered an individual town and was not confined by the laws of Bisbee. Many residents were displeased with the intrusion of denizens of Bisbee's Red-Light District. On one occasion, a prostitute, Nellie Bond, drunkenly walked through Lowell completely naked. Matters did not improve when a married couple, Con and Lillian Shea, who were notorious and often violent, moved their brothel to just outside of Lowell proper. Details of their volatile relationship were regularly reported in the *Bisbee Daily Review*. Once, when Lillian became "jealous of her husband when he was intimate with other girls in the house," she grabbed "an empty beer bottle [and] beat him to unconsciousness." Con was considered a vile character who worked "with his fists on the face and person of his wife." Far from helpless, Lillian fought back and, during one instance, stabbed him, barely missing his heart.

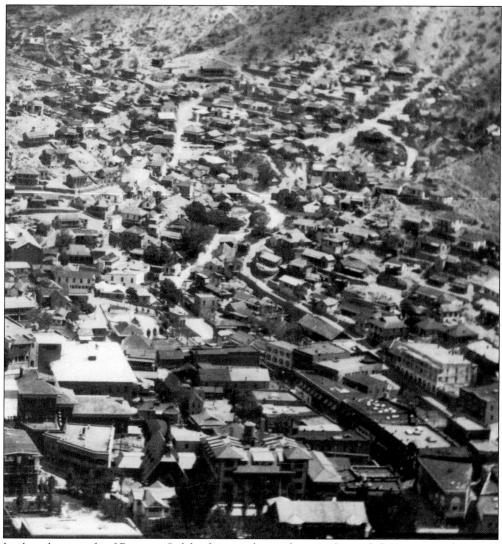

In this photograph of Brewery Gulch, the mouth is at lower right, and the street winds its way up to the Red-Light District near the upper left corner. Opium was available in Bisbee and could be found in the Red-Light District, where some of the ladies and their customers indulged in the vice. Cora Miles was arrested for a "hop layout" and for having a cigar box filled with opium at her ill-famed house. But, in keeping with the ways of the underworld, witness Pearl Phillips "forgot" seeing the mistress and customers smoking, and the case was dismissed. In 1909, after breaking up a "hop joint" and seizing a suitcase full of the poppy-derived drug, law enforcement suspected that three opium dens were operating in the Red-Light District. An infamous incident occurred when the "stunning" Mrs. Mabry attempted to entice three young girls into the immoral life. She invited the girls to a house on Naco Road for an oyster-and-chicken supper. At the home, she had them smoke opium and encouraged them to stay the night for "immoral purposes."

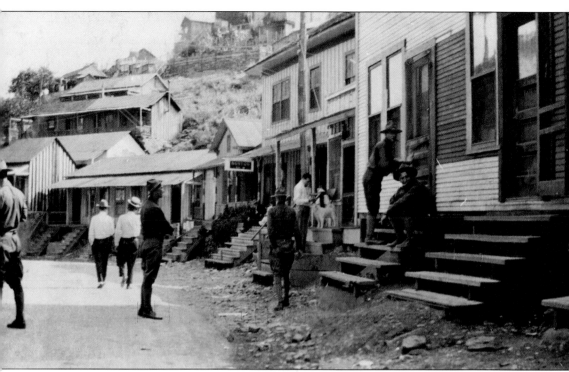

The Mexican Revolution brought soldiers to nearby Naco, Arizona. Although the fighting on the Mexican side was intense and filled the air with cannon and machine-gun fire, the American side was quiet. On leave, these bored young men, trapped in a camp in isolated Naco, flooded the city of Bisbee. As a result, the Red-Light District prospered. At the beginning of World War I, the 35th Infantry was permanently encamped near Lowell, within two miles of the ill-famed district. The secretary of war notified the mayor of Bisbee that it was illegal for such a district to be within five miles of a permanent military encampment. The city then passed a resolution closing the area for the duration of the war. At midnight on December 9, 1917, the last red light flickered and went out. The last stronghold of Western vices was gone. Bisbee was forever tamed. (Courtesy of the New Jersey State Archives.)

Six

MERRIMENT IN
THE MINING CAMP

By 1916, nearly 23,000 people called Bisbee home, making the mining camp one of the most populated communities in the Southwest. Recognizing this immense market, people in show business flocked to the city to entertain the mining camp. Theaters were erected, and traveling performers made Bisbee a regular stop on their routes. Silent films, as well as circuses, vaudeville, and Wild West acts, graced Bisbee's stages. Sporting events also became popular in the city, with many of the mining companies' employees making up sports teams.

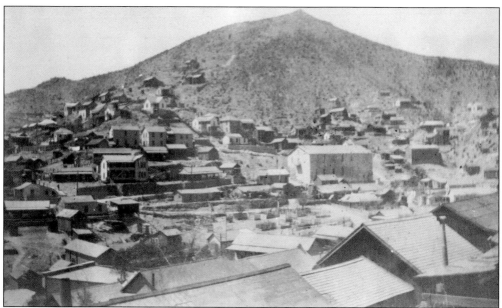

By 1894, there was an opera house in Bisbee. In 1897, a second opera house, the large white building seen here, was built. The second floor was used by secret societies. The building not only hosted operas; the theater treated residents to elaborate masquerade balls, mystical clairvoyants, and moving pictures.

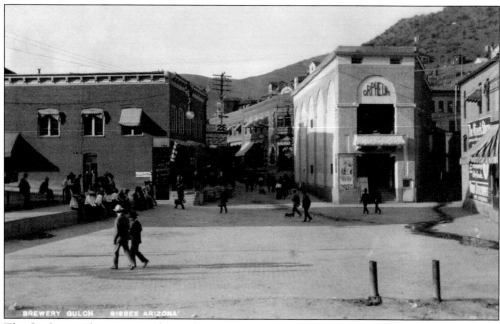

The Orpheum Theater opened to audiences in 1907, presenting the Frank Rich Stock Company. Located at the mouth of Brewery Gulch, the building was constructed with eight columns capable of holding 13 tons each. It had an expansive stage and numerous emergency exits. When not hosting plays, the theater was energized with images of silent-film stars, like Roscoe "Fatty" Arbuckle and Mary Pickford.

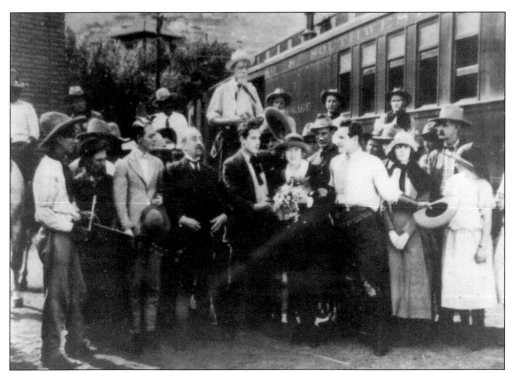

A few still photographs are the only remaining evidence of an undetermined silent film that was at least partially produced in and around Bisbee. In 1897, the community was the birthplace of silent-film actor Lloyd Hughes. He was a tall leading man, known for his stormy gray eyes and coffee-colored hair. (Courtesy of the BM&HM.)

Men of the community actively engaged in bowling, baseball, and "English football." Teams were developed largely from the mines where the players worked. The Holbrook and Sacramento mines fielded baseball teams, the Holbrook Highgraders and Sac Savages. Other teams were formed based on the line of work the men did, such as the baseball teams Assayers, Machinists, and Churn Drillers. Shown here is the Loretto Academy team.

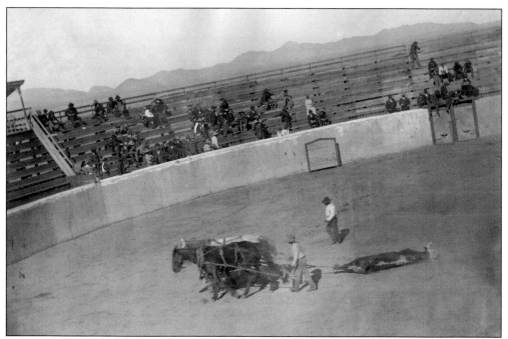

Residents of Bisbee kept prosperous saloons, supported a red-light district, and maintained social values that permitted a young lady to wear a see-through dress in town. But not all forms of entertainment were appreciated. Bullfighting was brought to nearby Naco, Mexico, with the hope of attracting spectators. However, the gory nature of the fights horrified the people of Bisbee.

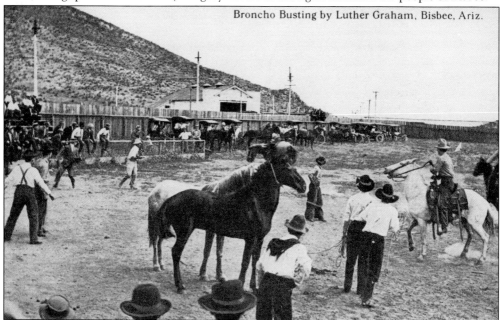

Broncho Busting by Luther Graham, Bisbee, Ariz.

Rodeos with some of the most famous cowboys of the Southwest came to Bisbee. These events included music, bronco busting, and wild mare roping and riding. In true Western fashion, roping and riding contests were regular features of these events. This photograph of Kenney's Wild West Show in July 1911 features the infamous bronco Bouquillas Roan and performer Luther Graham.

Bisbee became a stop for some of the best-known traveling performers in the world. The Ringling Brothers Circus visited the community in 1907. These were special events for the town; on occasion, children were allowed time off from school to attend the affairs. Performances were said to be so remarkable that they would linger forever in the memories of the children who visited. Guests were treated to a remarkable parade, featuring participants wearing ornate and unusual costumes. Then, residents wandered through animal-filled tents that included exotic creatures such as what was claimed to be the only rhinoceros in captivity, and 40 elephants. Within these tents, amazing performers gave such spectacular demonstrations that the *Bisbee Daily Review* said a man with an extra set of eyes "could have made a fortune." The stunts performed by humans and animals alike were "astounding," according to the paper. (Courtesy of the BM&HM.)

BISBEE
ONE DAY ONLY SATURDAY
September 28

PAWNEE BILL'S
WILD WEST

Performances Afternoon and Evening

Coming h.... in the Zenith of Its Glory; Coming with Every Honor New Y
and Europe Ca. Bestow; Coming with a Twenty-One Years' Record of Repea
Uninterrupted Su..... The Whole World Laid Under Contribution in Orde
Present an Exhibition in Keeping with the Name and Fame of Its Owner.

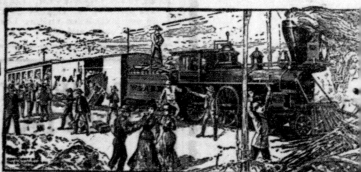

THE GREAT TRAIN ROBBERY

Bisbee became so popular that the circus and Pawnee Bill's Wild West Show played within days of each other. Pawnee Bill's show claimed to bring "A Living Page from Frontier History," and offered a different assortment of entertainment. The performances included reenactments of the Wild West, oddly, to a city that was not too far from that era itself. The show brought in over "100 Indians from half a dozen tribal nations." This included the 93-year-old Oglala Sioux Flat Iron, who was said to have spoken to the Sioux before the infamous "Custer Fight." According to the *Bisbee Daily Review*, other Native American men had been present at the fight, but they were "loth" to talk about the event. Performances included reenactments of stagecoach and train robberies, herds of buffaloes, horses, and some of the "crack shots of the Wild West."

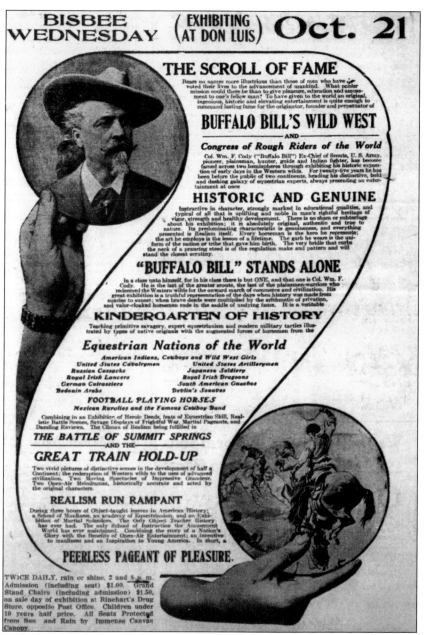

The Scroll of Fame advertisement for Buffalo Bill's Wild West, exhibiting at Don Luis, Bisbee, Wednesday Oct. 21.

Without a doubt, the most famous frontiersman to enter Bisbee was Buffalo Bill Cody. He spent many years entertaining and educating audiences on the American West across the world. His Wild West Show came to Bisbee in 1908 and 1910, and the troupe enthralled crowds. In 1910, Cody announced he was retiring from performing, something that was noted by the local newspaper. The article noted that this would be the last time Cody would climb on horseback in Bisbee. He stated that his retirement was "in recognition of certain natural laws that cannot be avoided." He simply wished to retire while in good health and spirits. The 1910 show offered 18 performances, representing acts from America and around the world. Fitting for the "silver haired legend," thousands of people turned out to say farewell to one of the most famous men in the nation's history.

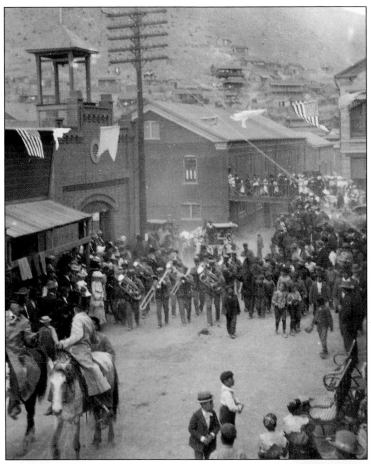

Parades played an immense part in entertaining Bisbee. When these events took place, residents from all parts of the district, donning their finest attire, would come to watch the procession on Main Street. These were held on holidays like the Fourth of July and Memorial Day, and included members of fraternal organizations, the military, and bands. One spectator recalled his childhood, when the sound from the footsteps of the soldiers, along with the blaring bands, reverberated in the canyon, giving him goose bumps as he watched and felt the parades go down Main Street.

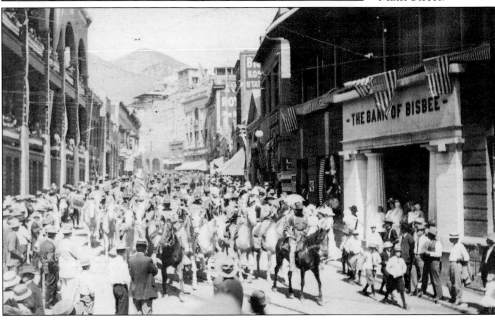

Seven

COPPER CAMP CATASTROPHES

In Bisbee's formative years, settlers drew upon resources readily available in the rural area to build the city, including the local wood supply and adobe bricks. Structures were assembled in close proximity to each other and to mine sites. It was essential that people lived near their workplaces. Buildings had to be constructed upon the canyon walls and on the floors of the Mule Mountains. However, residents soon learned the hazards of using such materials and the perils of these locations. Mother Nature unleashed many natural disasters, bringing the city to a standstill, leaving Main Street in ashes, and washing away homes. While the disasters suffered by the camp created setbacks in the city's growth, they were merely setbacks. With each catastrophe, the city learned and implemented new knowledge to generate a safer and more permanent community. With a resilient Western pioneer spirit, Bisbeeites created a community that would stand for generations. The city also faced social disasters, one taking place within the camp itself and one along the Mexican border. Unlike natural calamities, these social disasters left wounds that would take generations to heal.

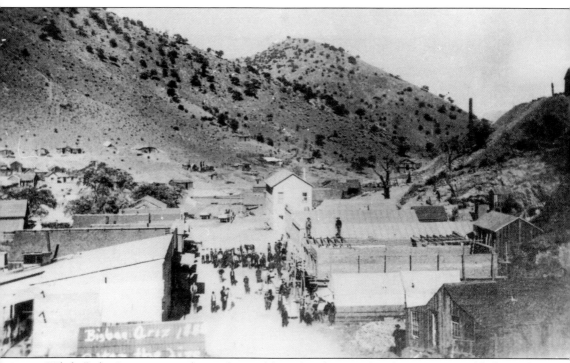

While Bisbee's success was due to the wealthy gifts of copper, Mother Nature would also strike devastating blows. The first took place in February 1885, when the *Tucson Weekly Citizen* reported that a bartender noticed "light shining through his window." Upon inspection, the man saw a pile of garbage ablaze in an alleyway off of Main Street. He fired several rapid gunshots into the air, recognized by the Western frontier community as an alarm. In minutes, a building was engulfed, and soon, the entire lower end of Main Street was held in a "fiery embrace." During the peak of the fire, an explosion occurred, resulting in a wall of flames that reached "80 feet in the air and scattering the blazing embers everywhere." By the time the fire was contained, the business district was destroyed. Witnesses to the event stated that they had never seen "a camp swept out of existence in so short a time." (Courtesy of the BM&HM.)

Another natural disaster rocked Bisbee in May 1887. The powerful shockwaves from a 7.2-magnitude earthquake in the Sierra Madre Mountains in Mexico shook Bisbee, giving the city quite a scare. Boulders rolled down the slopes of the Mule Mountains and onto the streets, windows rattled, dishes crashed onto floors, and chimneys tumbled from buildings. While the shaking was felt in the underground mines, the professionally constructed workings suffered only minor damage. Local legend has proclaimed that the large cracks along Bucky O'Neil Hill were caused by this earthquake. However, this is untrue; the cracks are a result of mining activity in the mountain. This subsidence resulted from large underground mine openings that were collapsing, causing the land's surface to shift and sink. As mining continued, this became an ever-increasing problem. These cracks can be over 20 feet wide, hundreds of feet long, and appear bottomless.

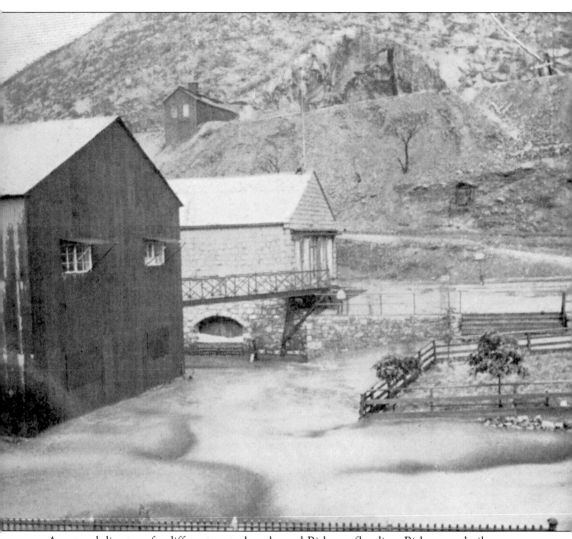

A natural disaster of a different sort also plagued Bisbee—flooding. Bisbee was built upon one of the most picturesque portions of the Mule Mountains. The heart of the community lay at the convergence of three canyons, with mountainsides lined with lush oak trees. However, with the arrival of the early settlers, the verdant mountains soon appeared more like desert valleys, as the large trees were cut down for use in buildings and for fueling fires. Although necessary for the mining camp's progress, the community's location, coupled with alterations to the landscape, put residents in the path of danger. Torrential monsoon rains during the summer fell from the sky at such a rapid rate that the barren and dry soil could not absorb the water. The rain then poured down the mountainside and collected in the canyons, resulting in deadly floodwaters raging in the mining camp, as seen here in the 1890s.

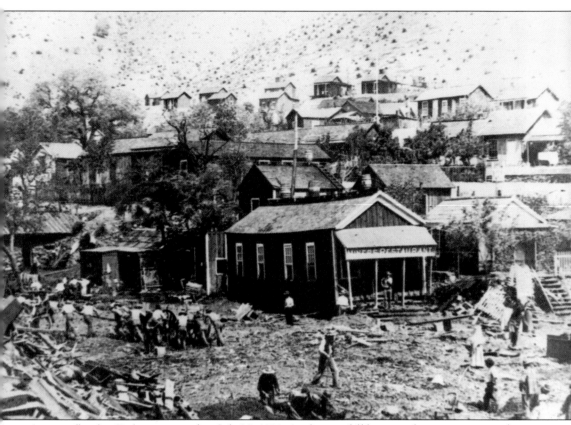

A major flood in Bisbee occurred on July 28, 1890. As the rainfall began, it became apparent that this storm was not a friendly visitor. Rain forcefully pelted the city, accompanied by lightning that the *Tombstone Prospector* called a "livid glare" and that put fear into the hearts of residents. The lightning was accompanied by the shrieks of frightened inhabitants. People rushed to their homes, seeking refuge from the violent storm, but the rainfall quickly turned into torrents that raged down the canyons. Not even their abodes offered safety to the residents. The exploding thunder was now coupled with the cracking and crashing of homes being ripped from their foundations, washing away everything inside, even the occupants. Men screamed for their lives as they were swept into the forceful and merciless waters. People rushed to their aid, but for some, it was to no avail. Next came the monumental task of cleaning up the devastation.

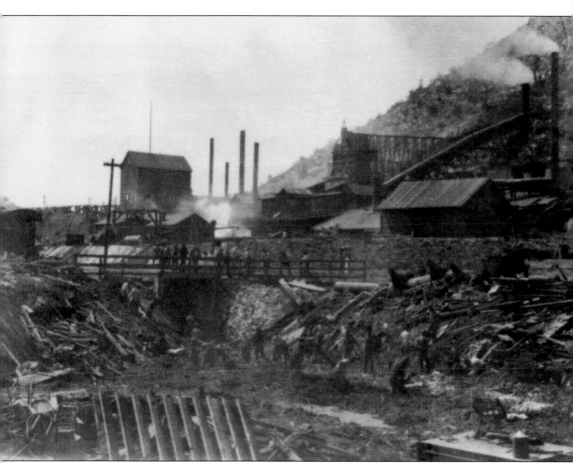

At the time, the 1890 flood was the worst disaster ever faced by the mining camp. The scale of the tragedy was painfully evident when the floodwaters receded and residents ventured onto the streets to gaze upon the destruction. Along with the heartbreak of witnessing their town in shambles, residents also had to deal with the human toll. Over 100 men from the Copper Queen Mining Consolidated Company searched through the extensive field of rubble to find two men who were counted as lost, but their lives had been extinguished by the floodwaters. This photograph, looking southeast toward the Czar Mine, shows piles of wood, metal, and rock blanketing the road. People at center and in the foreground clear away the debris as they search for the men who were swept away by the raging water.

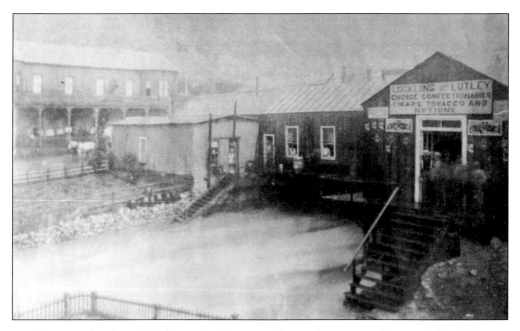

Another major flood struck Bisbee in October 1896. The *Tombstone Epitaph* reported that hailstones, "some the size of hen's eggs," fell upon the city continuously for 20 minutes. Numerous buildings could not withstand the "prolonged battering," which broke windows and even destroyed metal roofs. About 15 minutes after the hail started, the floodwaters entered the canyons. The city was now accustomed to flooding, but the waters reached levels residents had not witnessed in years. This resulted in significant loss of property, including entire homes that were carried away. (Both, courtesy of the BM&HM.)

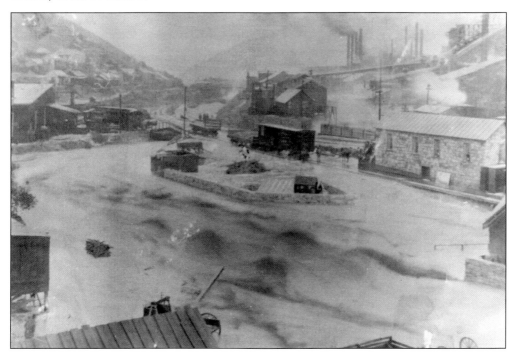

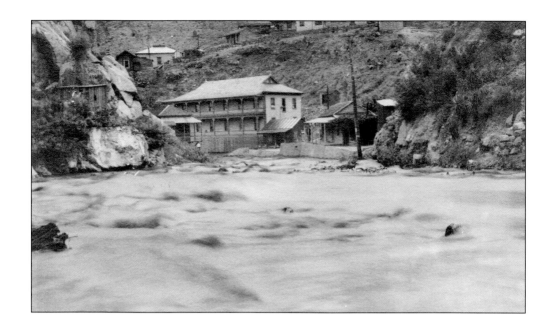

Numerous floods intruded upon Bisbee's canyons and the lives of residents. With time, precautions were taken to protect the public and their property from the torrents that wreaked havoc in the canyon city. Anything of value was kept high and out of reach of the floodwaters, including homes, which were often elevated off the canyon floors. Retaining walls offered added protection. Those who unwisely did not respect the power of Mother Nature and chose to traverse the waters or observe the flow from an insecure location often found themselves swept away.

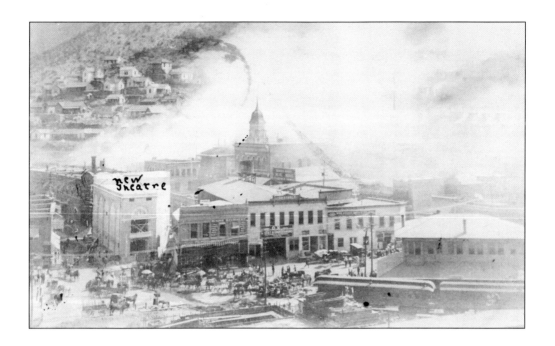

In June 1907, fire again struck Bisbee. The blaze began at the intersection of Brewery Avenue and OK Street and moved rapidly up to Chihuahua Hill, where homes were built tightly together and quickly burned. Wind and low water pressure impeded the attempts of firefighters to battle the blaze. Residents and miners assisted the firemen. By implementing bucket brigades and blowing up houses to create breaks in the fire, the blaze was eventually extinguished. The flames terrorized Bisbee for three hours. By the time it was put out, over 100 families had lost their homes.

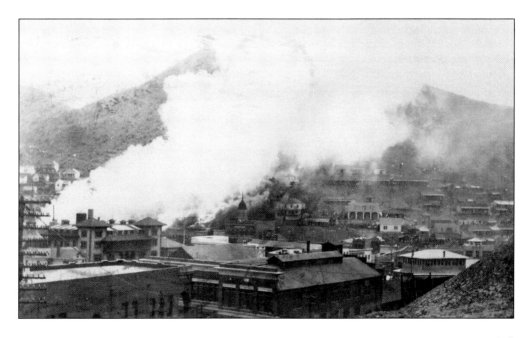

By 1908, the city was indisputably one of the mightiest copper camps in the world, and possessed a robust economy to prove it. However, that year tested the strength of Bisbee and stands as its most devastating. Troubles began on August 4, when the residents were treated to a hospitable day with an almost clear sky. A powerful monsoon storm quickly entered the city, swallowing the afternoon sunlight and overwhelming the camp with rain. Residents were likely accustomed to such a scene, as water began to accumulate in the canyons and flow down the streets. However, a tremendous landslide occurred behind the south side of Main Street. This caused water to build up and stream into the rear of the businesses. The water then surged through and poured out the front of the stores.

The landslide behind Main Street was massive. An estimated 1,500–2,000 tons of rock and debris piled against the building where the city library is located, reaching the second floor. This enabled water to penetrate the library's reading room. The above photograph captures water pouring off of the library's second-floor porch. Boulders crashed through windows into the rear of the buildings, causing the occupants to dash for their lives. This was the case at the post office (below), where employees fled to escape the onslaught of rock and silt that poured into the building. (Below, courtesy of the BM&HM.)

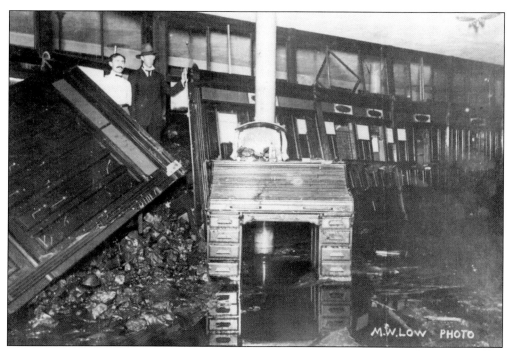

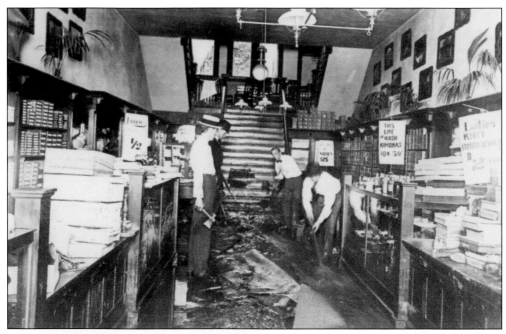

Once the rain stopped, life in the camp quickly resumed. With water and mud coating the floors, one saloon began to play lively piano music, and customers waded up to the bars to continue their indulgences. Some patrons joked about needing their bathing suits, and others inquired as to when the "next boat left for the post office." In the days that followed, an enormous cleanup effort took place to remove the material from the landslide. Railcars were moved in behind the post office and loaded with the debris (left). (Above, courtesy of the BM&HM.)

Bisbee's cleanup efforts were in vain, as six days later, on August 10, another flood tore through the city. More rocks poured from the Mule Mountains and into the post office. Although planks had been placed over the windows for protection, they were quickly annihilated. Once again, the post office was inundated with water and rock. Postal clerks hastily attempted to retrieve stamps and mail before they were swept away. Other businesses along Main Street were quick to put up floodgates, which saved them from significant damage. A steam shovel (below) was later brought in to remove the material left from the landslide.

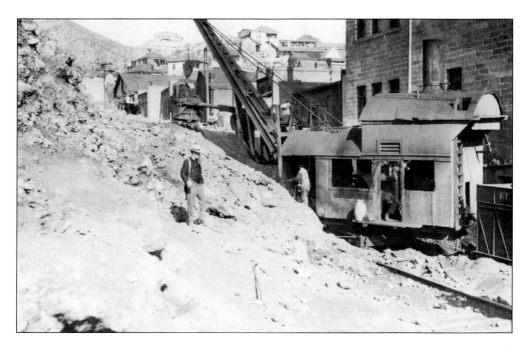

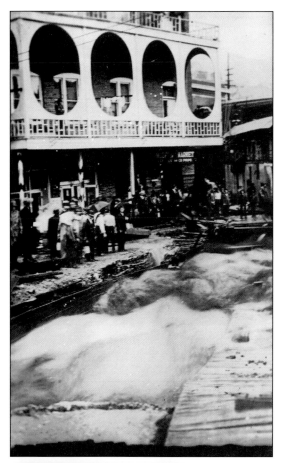

Once again, as soon as Bisbee shoveled and swept its way out of the destruction of the past floods, another hit. However, the flood of August 24 would be the worst. The rain that rolled in during the late afternoon brought with it a fierce electrical storm. The *Bisbee Daily Review* stated that the "heavens were rent with sharp peals of thunder and vivid flashes of lightning." The heaviest portion of the storm was along Tombstone Canyon and raged down the thoroughfare, making the street impassable within 15 minutes. As the storm continued, one of the most dangerous scenarios imaginable played out. People along the midsection of Main Street noticed that the road above the underground waterway system, created to divert water, was about to collapse.

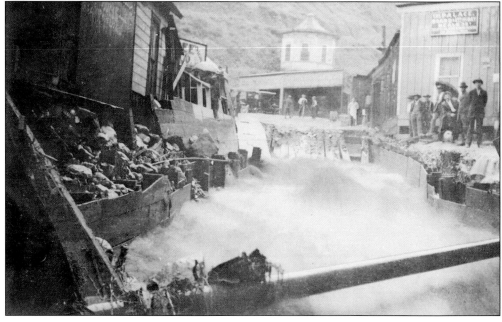

The road crumbled before the eyes of onlookers. A giant wave of water rushed down the channel, causing debris from the wrecked subway system to crash down lower Main Street. Water violently raged down the exposed waterway and was particularly brutal at the end of Subway Street, where it was photographed having immersed an entire floor of a building. (Courtesy of the BM&HM.)

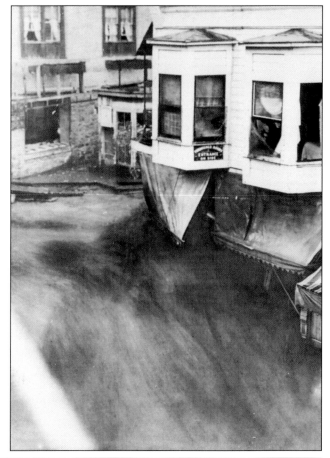

In only 50 minutes, two-and-one-quarter inches of rain fell. Had the waterway not failed, the level of damage would not have been so severe. Bisbee was left tattered. An immense gulf was left over the failed channel, and Main Street was in shambles. Fire, sewer, and gas mains were broken.

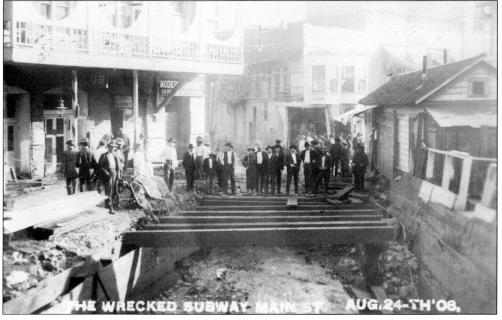

THE WRECKED SUBWAY MAIN ST. AUG. 24-TH '06.

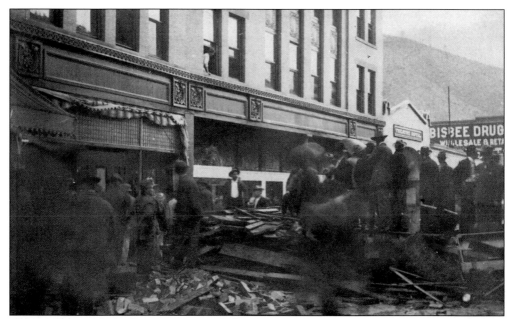

The wreckage of the broken waterway, including bricks and large planks of wood, were strewn over lower Main Street. The force of the flood caused debris to flow several hundred yards down the business district, damaging businesses along the way. Most of the local jewelry store's merchandise washed away, and the Fair Store suffered a sizable loss of goods.

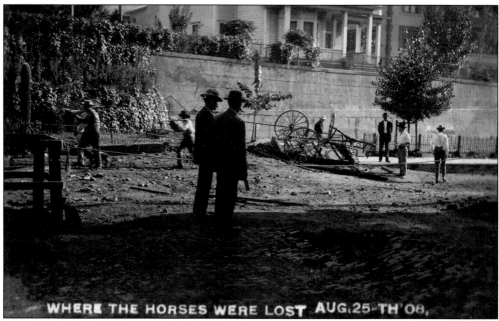

WHERE THE HORSES WERE LOST AUG. 25-TH '08,

While the flood did not take a human toll, it did kill animals. A train had just arrived as the flood began, and a large crowd of passengers witnessed horses being swept into the current. Men watched helplessly as the horses were carried off into the torrent. To attempt a rescue would have been suicide.

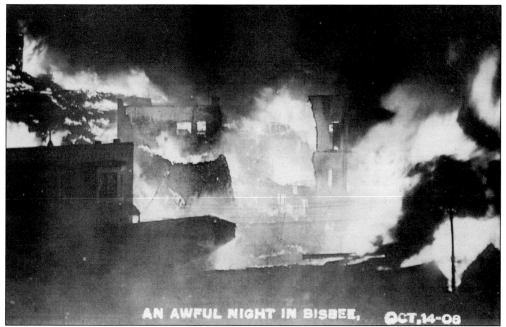

Bisbee's final tragedy of 1908 took place on the evening of October 14, when a fire began in the Grand Hotel on Main Street. Spreading rapidly, it soon engulfed the entire three-story building. Occupants of the structure made daring escapes as they fled for their lives. One man jumped out of a third-story window and into a blanket to save himself from the flames.

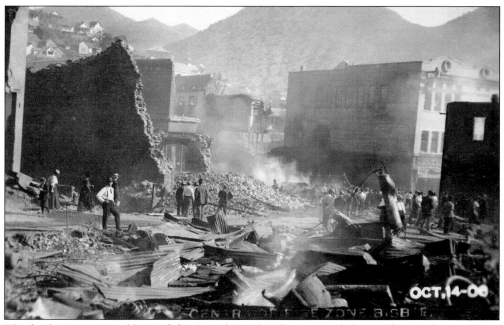

The fire began to spread beyond the Grand Hotel and soon traveled up and jumped across Main Street, endangering the entire commercial district. Those who owned businesses in the path of the fire rushed to remove furniture and stock from their property. It was painfully evident to all that the inferno's hunger would not soon subside.

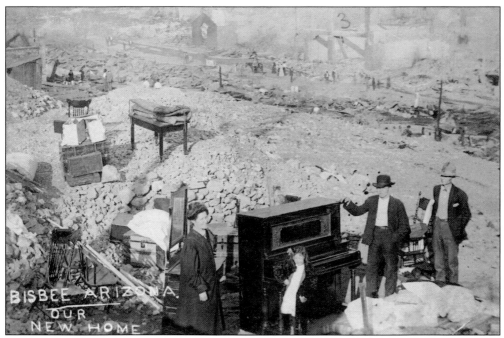

The commotion that ensued resulted in the streets being filled with people who had become separated from their loved ones. The *Bisbee Daily Review* stated, "Women searched for their husbands, husbands for their wives, [and] children for their parents." For many of these distraught people, there would not be a home standing to return to after the fire.

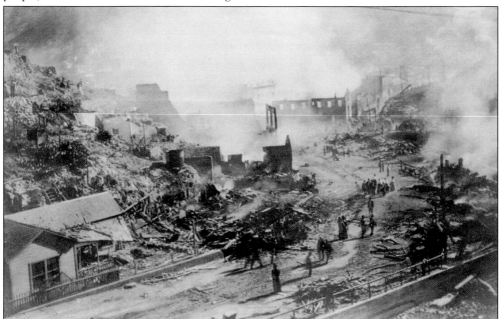

Bisbee was trapped in the terrorizing clutches of the fire for three hours. The intense glow of the blaze was visible over 100 miles away. Finally, dynamite was used to demolish buildings where Main Street ends and Tombstone Canyon begins, which created firebreaks. The thunder of the blast was so intense that it reportedly caused women to faint.

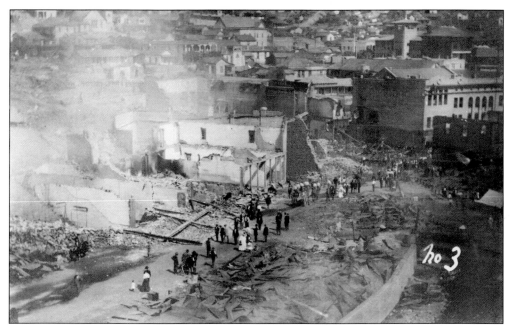

Over 500 people were suddenly left homeless. Offers of assistance for the victims poured into Bisbee. However, the city politely declined, as such a giant outpouring of help came from within the community that additional aid was not needed. According to the *Bisbee Daily Review*, the city met the "situation in proper spirit and no one [was] allowed to suffer." Victims were given shelter, clothing, and food from both businesses and community members.

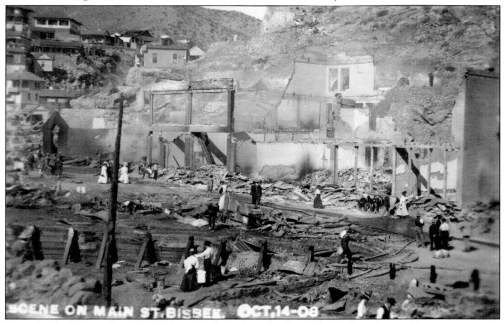

Over half of Main Street was destroyed, with only charred wood and crumbling stone walls remaining. The total damages reached $750,000. Although such an event may be a defining moment in the decline of a city, it was not the case for Bisbee. It used the tragedy to rebuild a stronger, more permanent city.

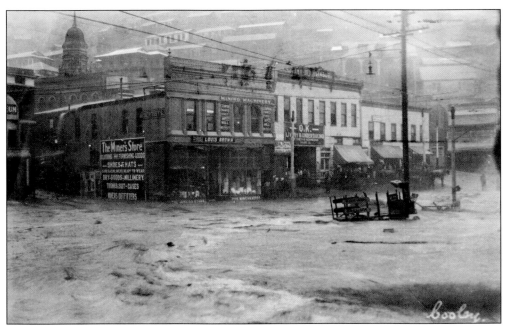

In 1910, the monsoon season brought another devastating flood to Bisbee. The rain began in the late afternoon of July 22 and gathered in the canyons with an awe-inspiring force. The flood-prevention methods implemented by the city, including lining Brewery Gulch with cement walls and installing a subway system, were of tremendous value during the event. However, the amount of water pushed these measures beyond their limits. Large retaining walls collapsed, the flood channels overflowed, and rivers of water, filled with debris of all sizes, raged through the city's canyons. Homes in Brewery Gulch were among the first to be robbed of their contents, including family pets that were whisked away into the clutches of the fierce water. Soon, portions of houses joined the deluge down the canyon.

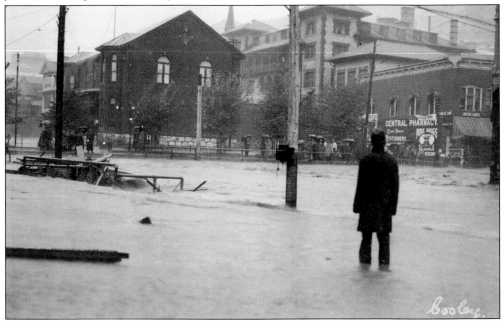

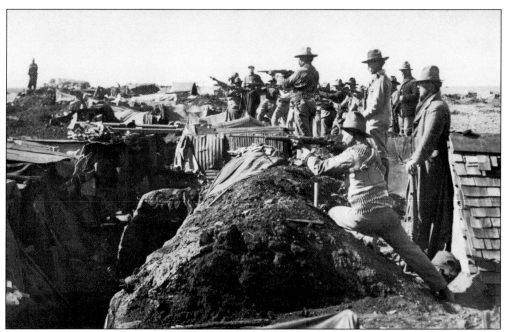

Starting in 1911, disasters occurred on Bisbee's social front. The Mexican Revolution traumatized the town. Fighting began to intensify seven miles south at Naco, Mexico. On April 8, 1913, the Battle of Naco occurred. It was reported that no building and almost no tents on the American side of the border were spared bullet holes. During the fighting, three American soldiers were wounded, and the desert was now a field of death. As troops were unable or unwilling to bury the fallen, bodies were burned where they fell. The quiet landscape was continually disturbed by scattered gunfire and cannon blasts. The years 1914 and 1915 proved no less bloody, as Naco was besieged and endured 119 days of battle. By the end of the siege, residents of Bisbee completely understood the horrors of war. (Above, courtesy of Library of Congress.)

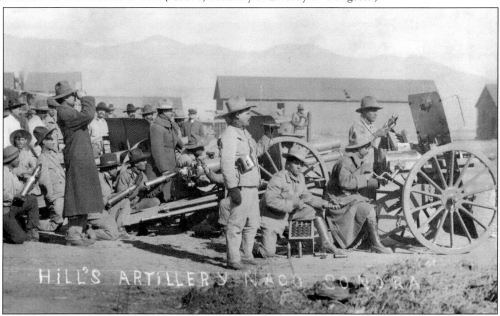

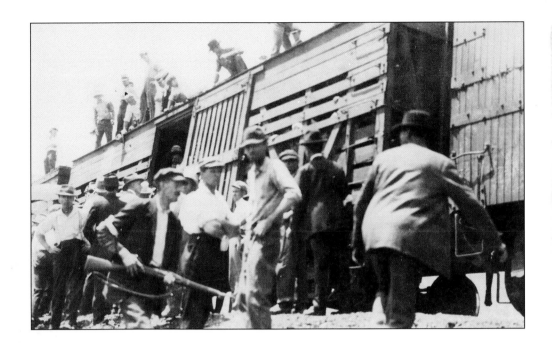

A disaster of a different sort took place in Bisbee on July 12, 1917. On this day, over 1,000 people, including Industrial Workers of the World mine strikers and their supporters, were rounded up at gunpoint and taken to the Warren Ballpark. From there, they were deported to Hermanas, New Mexico. As the men were forcefully removed from their homes, some barely had time to get dressed, and wives pleaded for their husbands. Under US government law, this was a mass kidnapping. Ultimately, the courts dropped the kidnapping charges, citing the law of necessity.

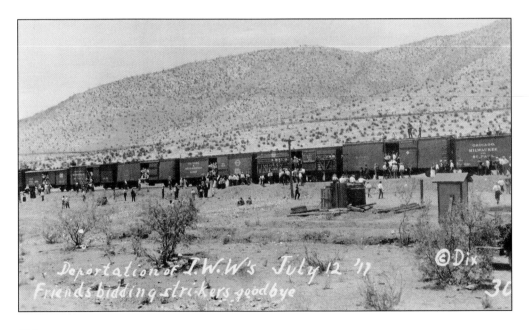

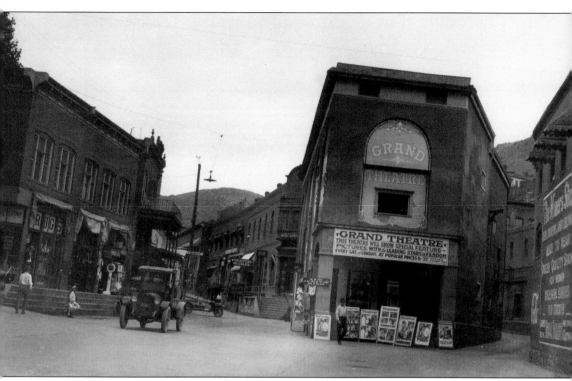

Mule Gulch slowly evolved, beginning about 11,000 years ago, when mammoths were hunted along the nearby perennial streams, and through the years of the Chiricahua Apache. With the discovery of copper in 1877, the rate of change exploded. The last decades of the 19th century were beset with outlaws, the fear of Apaches, and primitive transportation. By 1912, the Arizona Territory proudly became the 48th state in the Union. The hard-fought battle to achieve statehood was won! Within five years, Bisbee was no longer the Wild West. Social change had swept away the vices of the past. Gambling, drinking, and the Red-Light District had met their demise by the end of 1917. Single, foreign-born miners were now the minority, and married couples guided the development of the town. The community built a respectable education system, a robust infrastructure, and an effective municipal government. Yet, Bisbee remained at heart a mining town, an essential part of booming industrial America.

DISCOVER THOUSANDS OF LOCAL HISTORY BOOKS FEATURING MILLIONS OF VINTAGE IMAGES

Arcadia Publishing, the leading local history publisher in the United States, is committed to making history accessible and meaningful through publishing books that celebrate and preserve the heritage of America's people and places.

Find more books like this at
www.arcadiapublishing.com

Search for your hometown history, your old stomping grounds, and even your favorite sports team.